Fireworks 4th of July 2019

Highland Bayou, Texas – Louis' Bait Camp & Restaurant

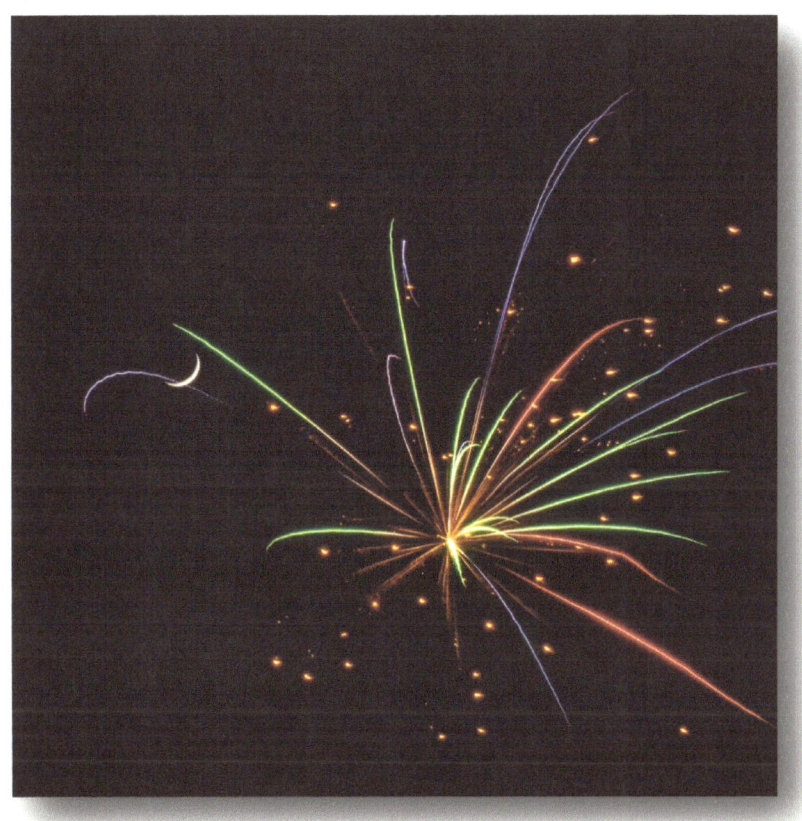

Author & Photographer -- Susan Scott Smith

This photo album is dedicated to my dear mother, Shirley, whose caring, creative life came to an end at the age of 89. She is missed, remembered and still inspires those left behind to give 100% 24/7.

Table of Contents

Pyrotechnics . . . aka Fireworks..**1**

Photography..1
The 4th of July 2019..2
Simplicity (Monochrome)..5
Complexity (Chromatic)...13

Susan Scott Smith...30

A Special Thanks To ..31

Pyrotechnics . . .
aka Fireworks

As with many youngsters, I was fascinated by fireworks. If we went to an event it was wonderful and if we held our own event at home, it was even more wonderful.

Photography

When I was young I loved taking pictures. This continued through adulthood where volumes of photo albums were created and still cherished.

After retiring from teaching, a friend suggested we take a hobby photography class at COM (College of the Mainland 50+ Program). It was only $15 so I said, "Yes" and brought my iPhone with me . . . it was the camera I used at the time.

"The best camera is the one you have with you." *Trudy LeDoux*

I took the beginners' class once and have taken the intermediate almost every semester since. Our instructor, Trudy, has many repeat students and just ups-the-ante each semester.

The iPhone is still one of my tools but the two used for these photographs are Sony cameras. One is a bridge camera—an RX10M3 and it is terrific. The other is an a700 which I am getting accustomed to.

With the 4th of July approaching, I reached out to our class to see where students were taking photos of the celebration and Paula invited me to join her for the 4th of July fireworks near her home.

So, there it is . . . enjoy!

The 4th of July 2019

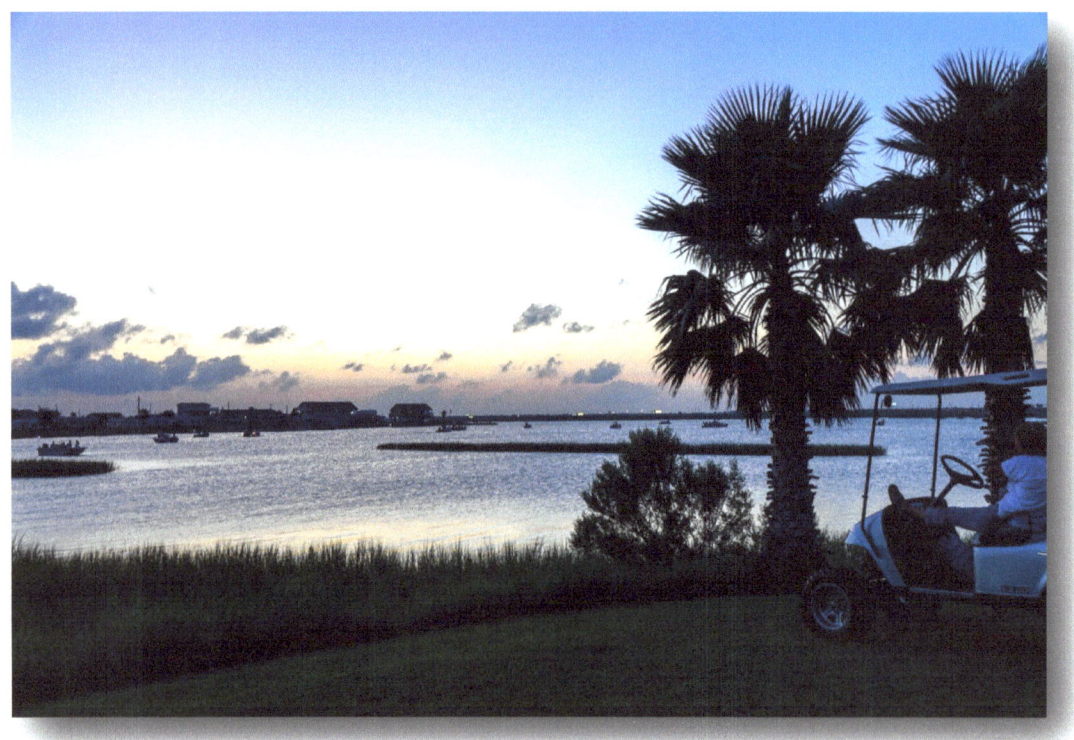

Many onlookers are ready for darkness to fall . . . we were surrounded by residents in their golf carts ,chatting and eagerly awaiting the light show. It is a gorgeous evening. One neighbor commented that we should have more than two times in the year to shoot fireworks.

Twilight arrives, and we hear fireworks in the neighborhood. If you look closely you can see a sliver of a moon high in the sky and on the right of the fireworks explosion below.

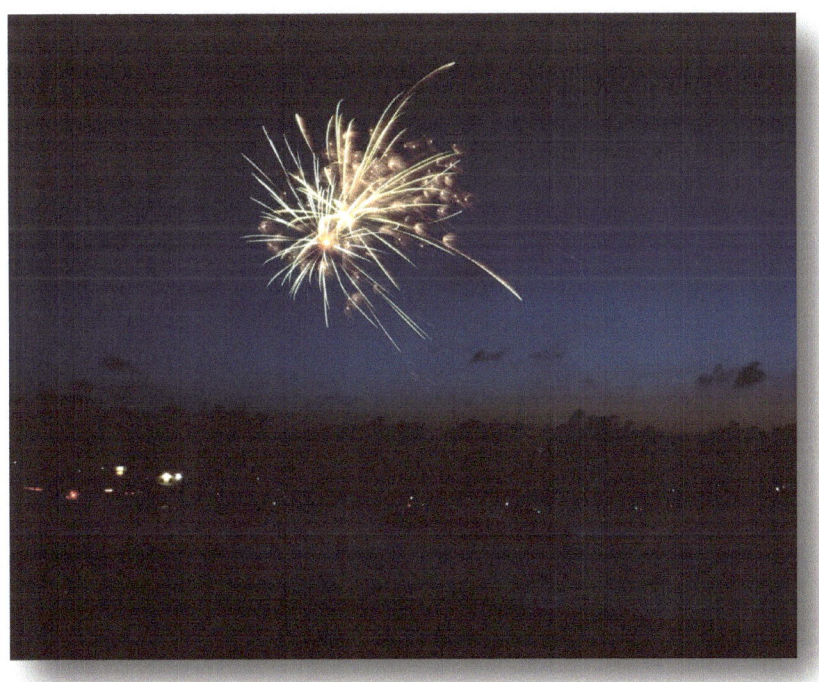

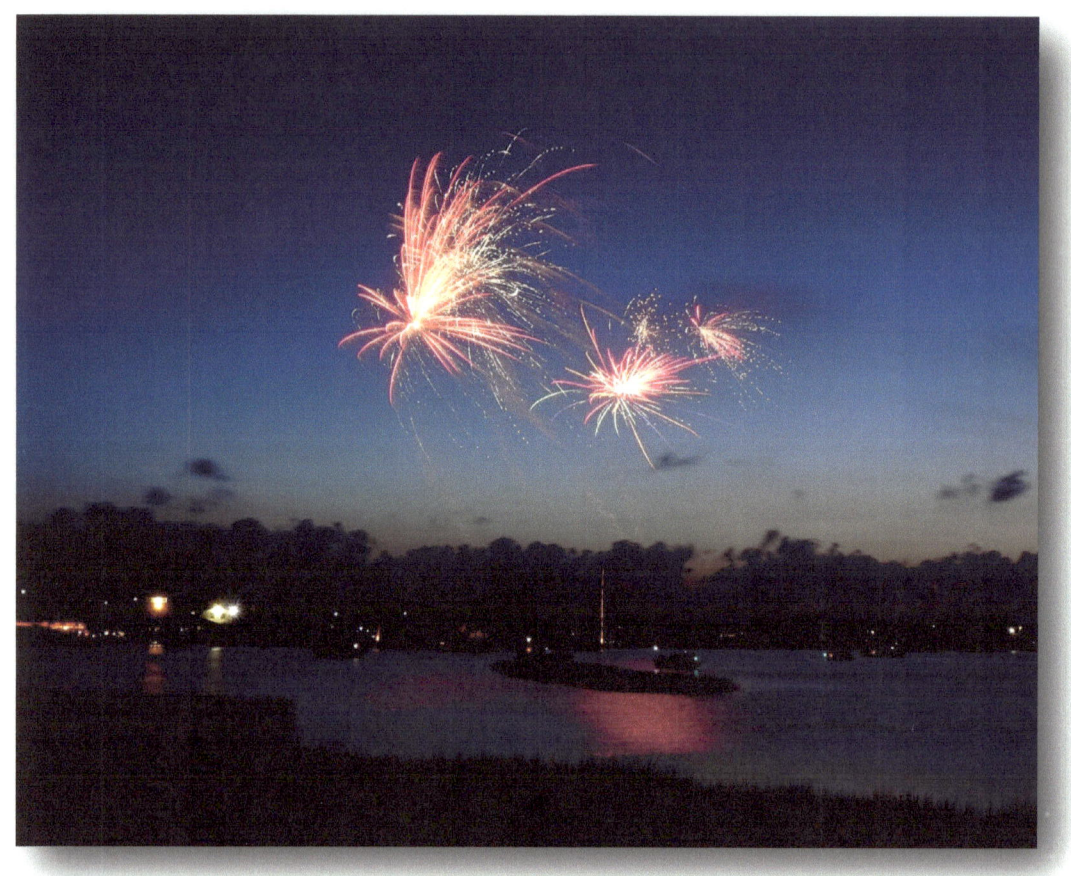

I love the reflection on the water. It was a beautiful, clear night with a very mild breeze. The bridge to the left was filled with parked cars whose occupants were enjoying a magnificent show.

Simplicity (Monochrome)

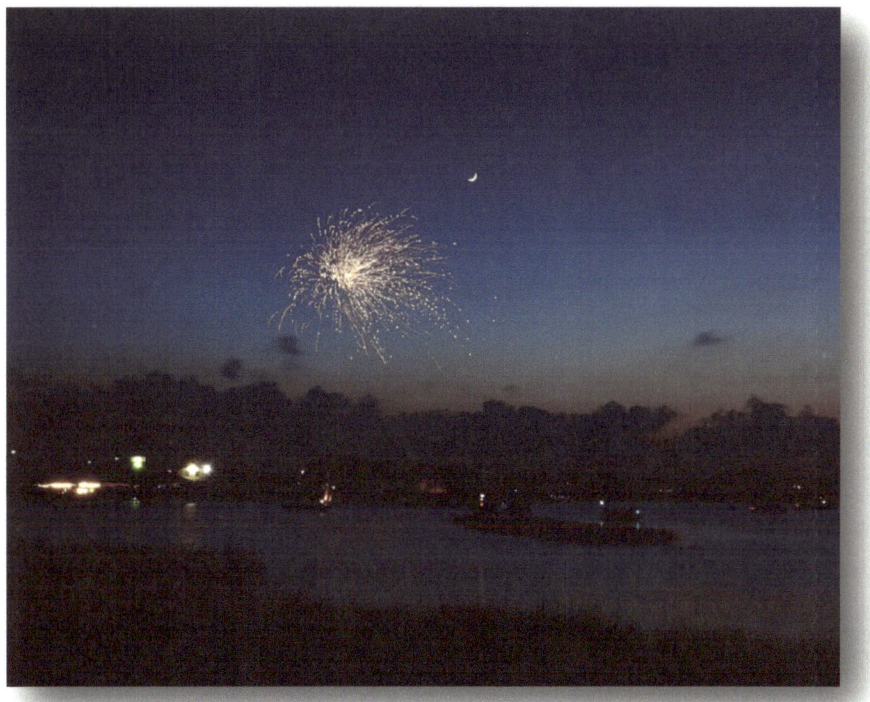

The moon really stands out in these.

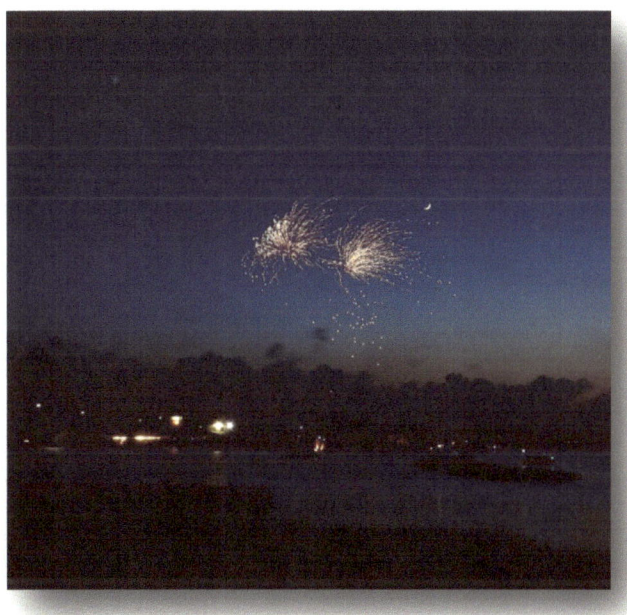

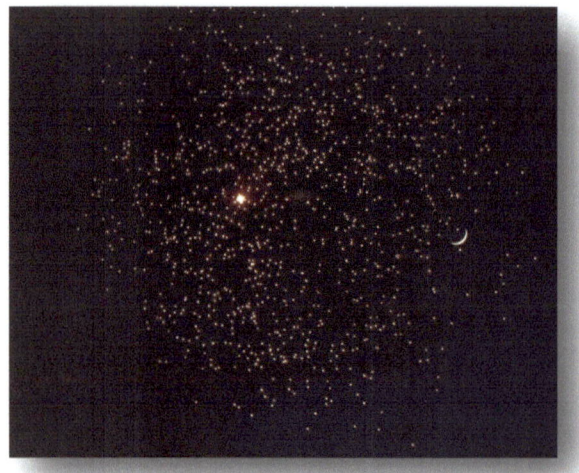

Looks like stars . . .

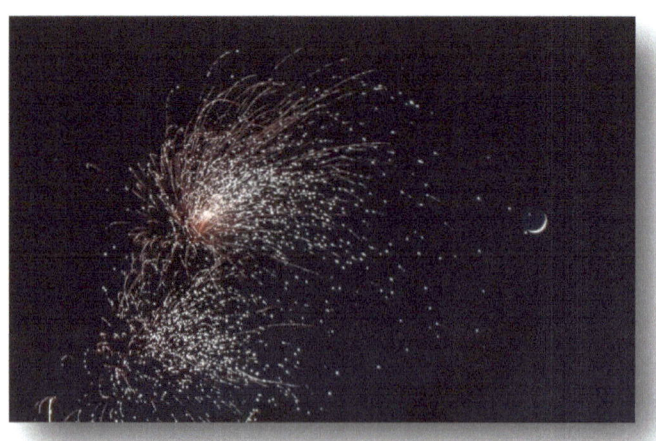

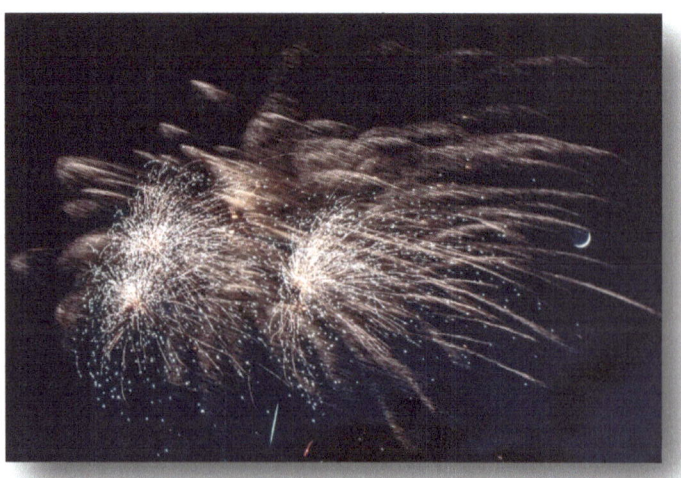

. . . and galaxies . . .

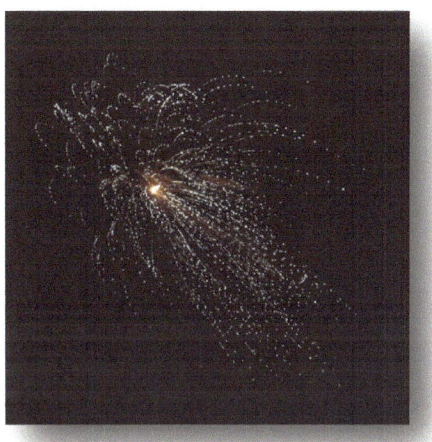

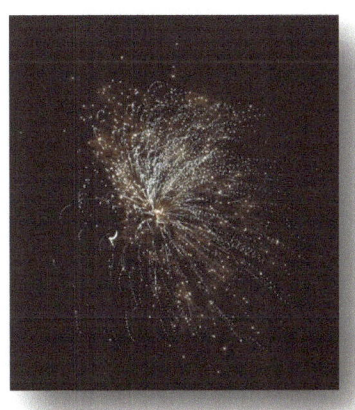

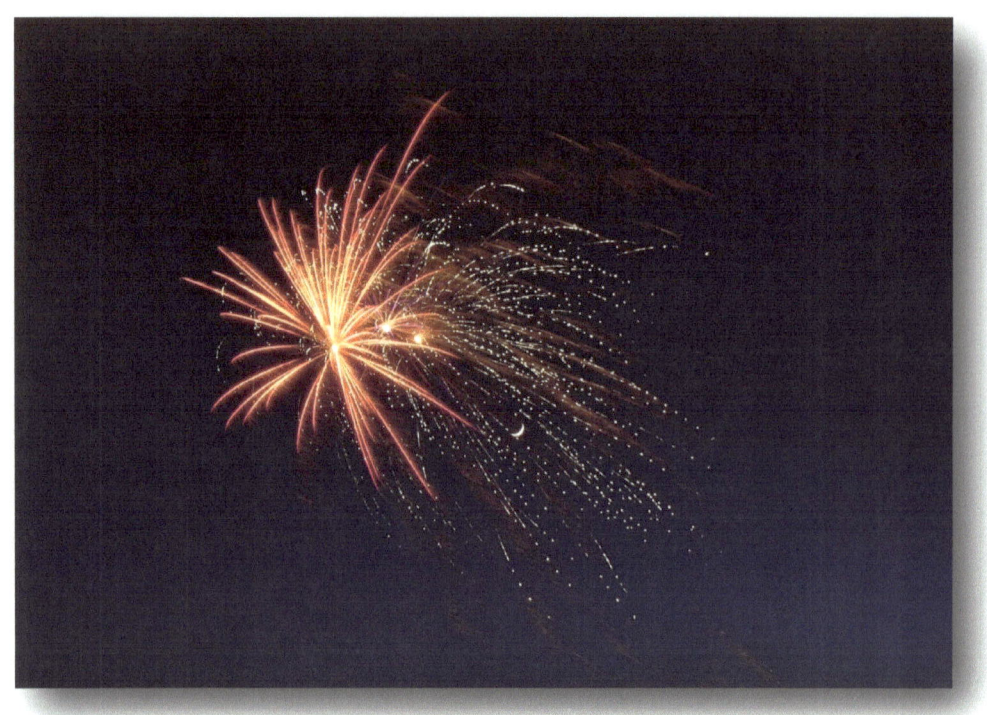
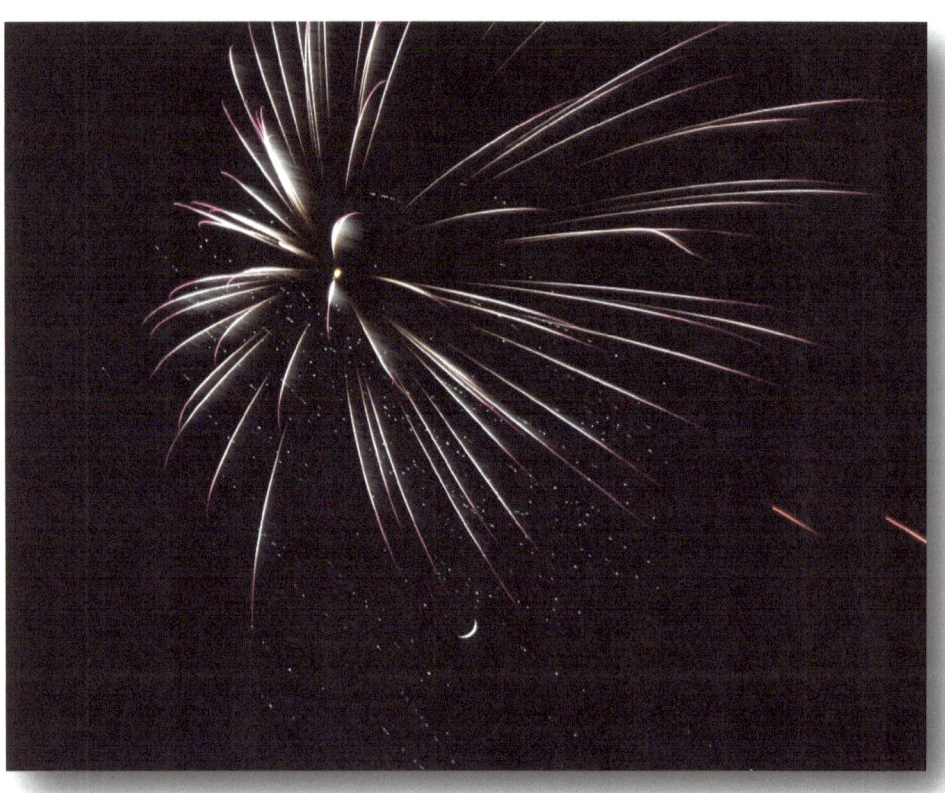

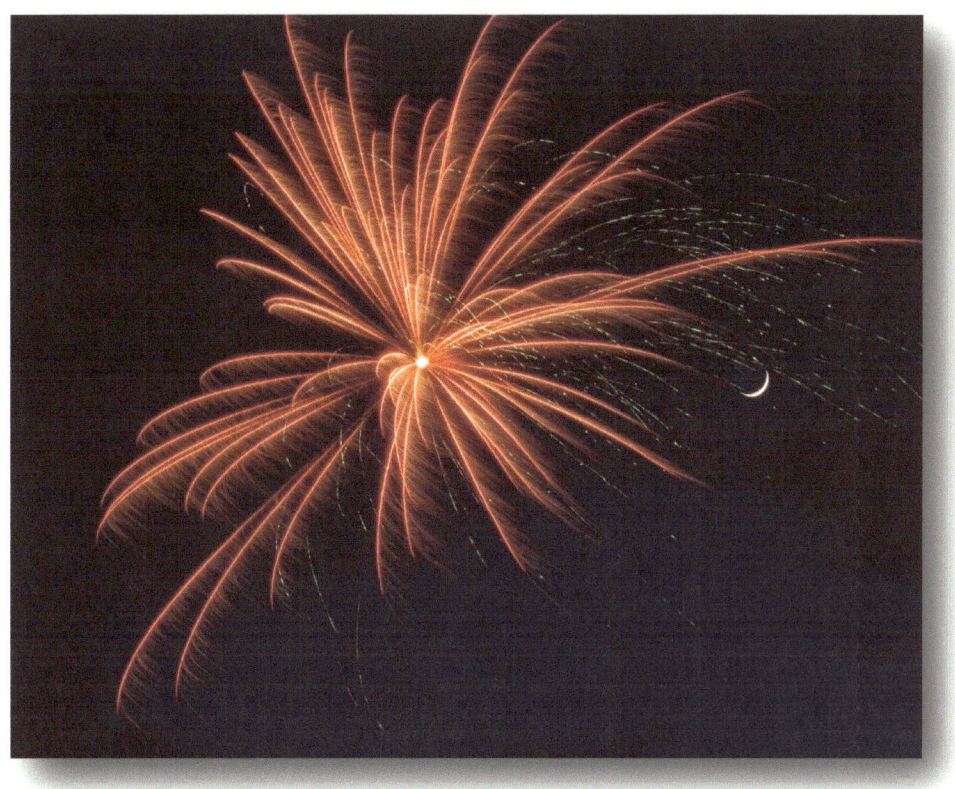

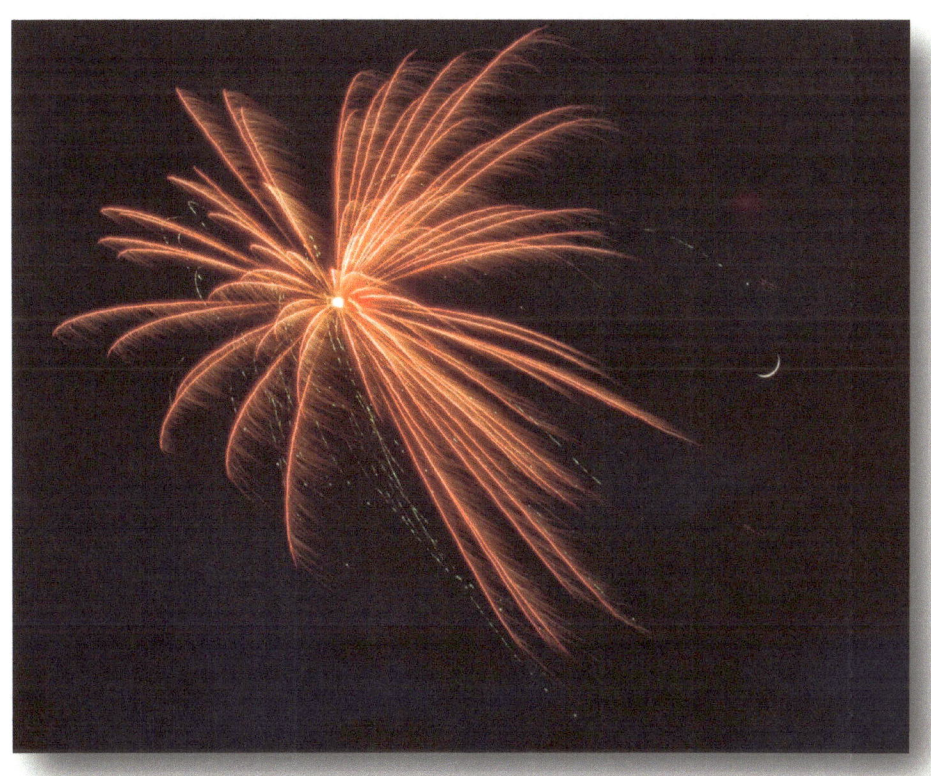

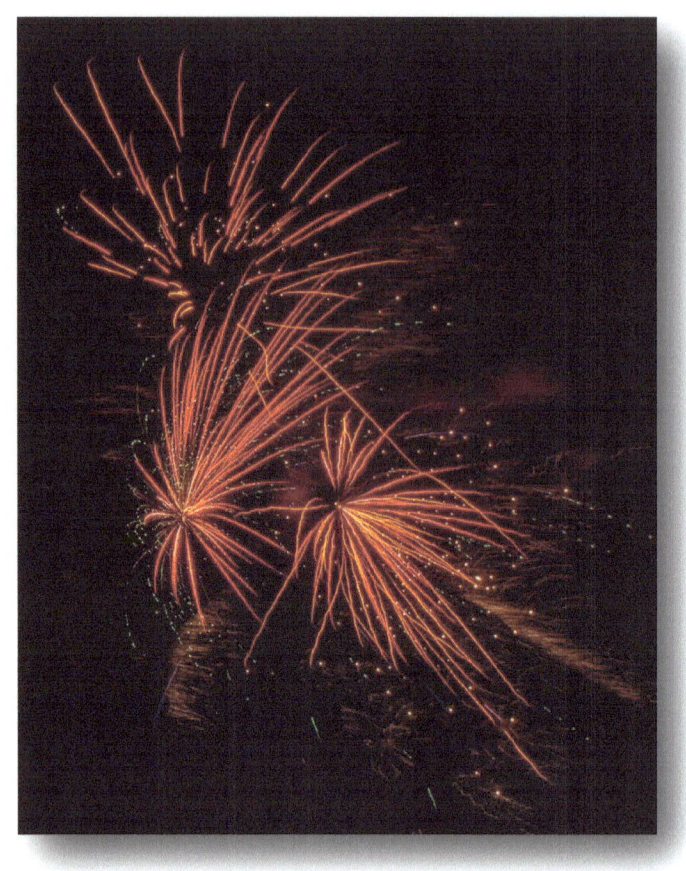
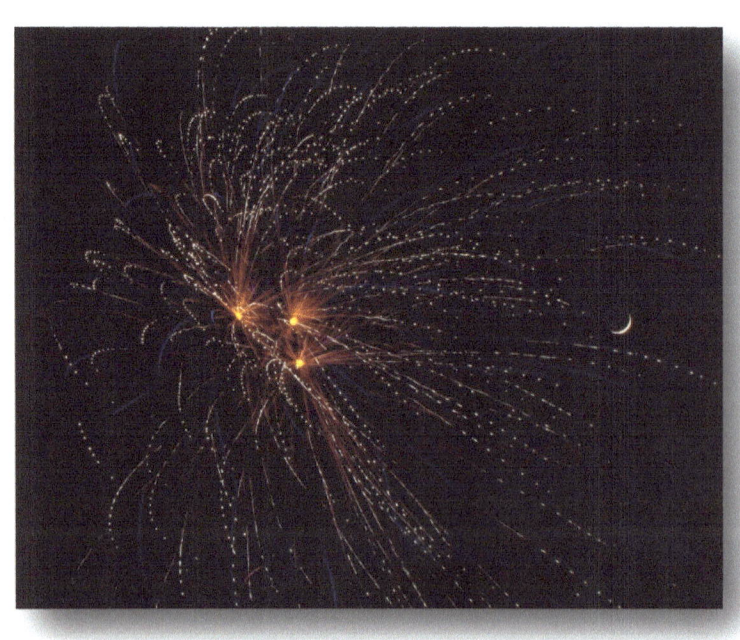

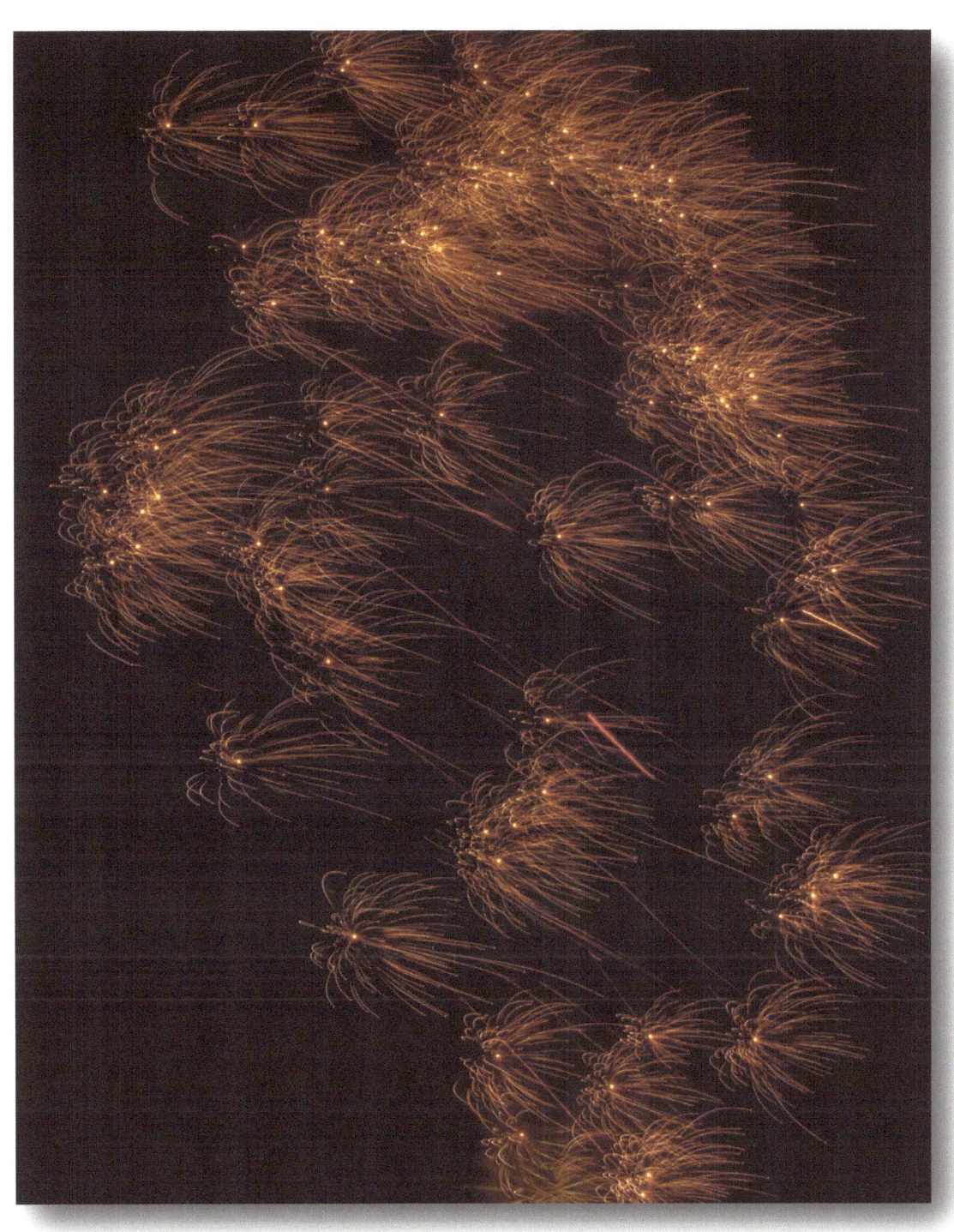

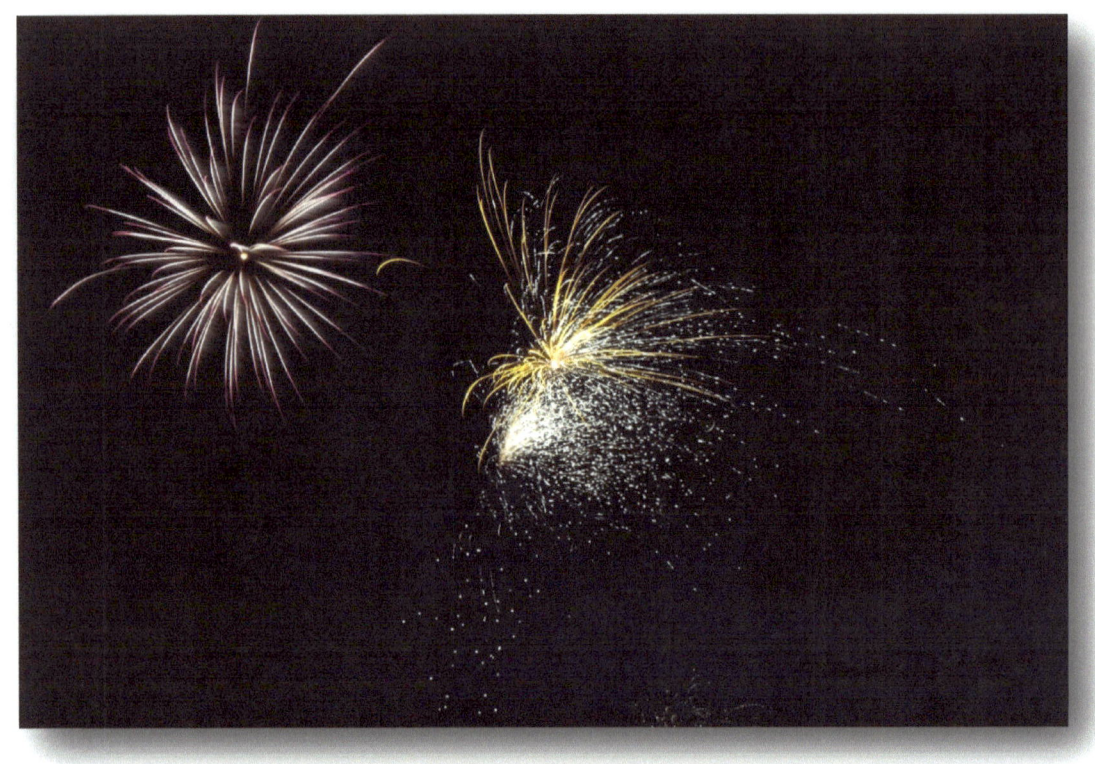
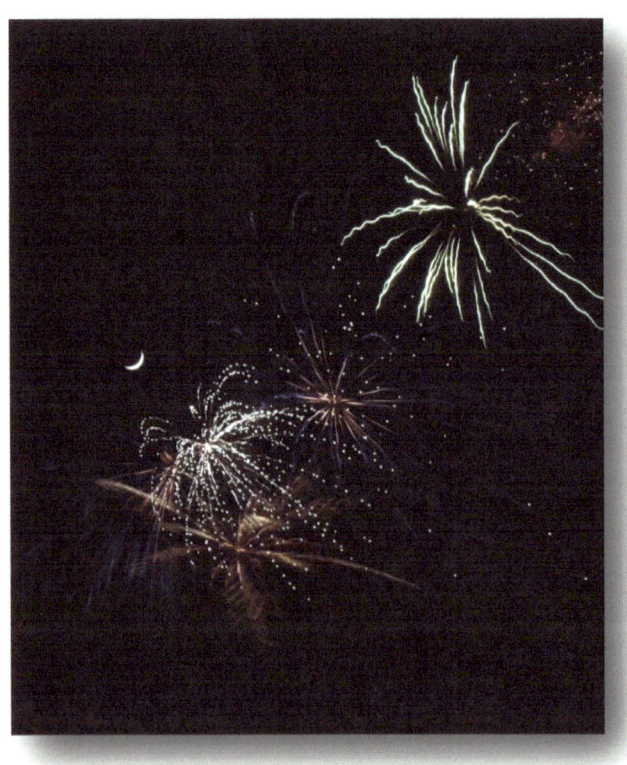

Complexity (Chromatic)

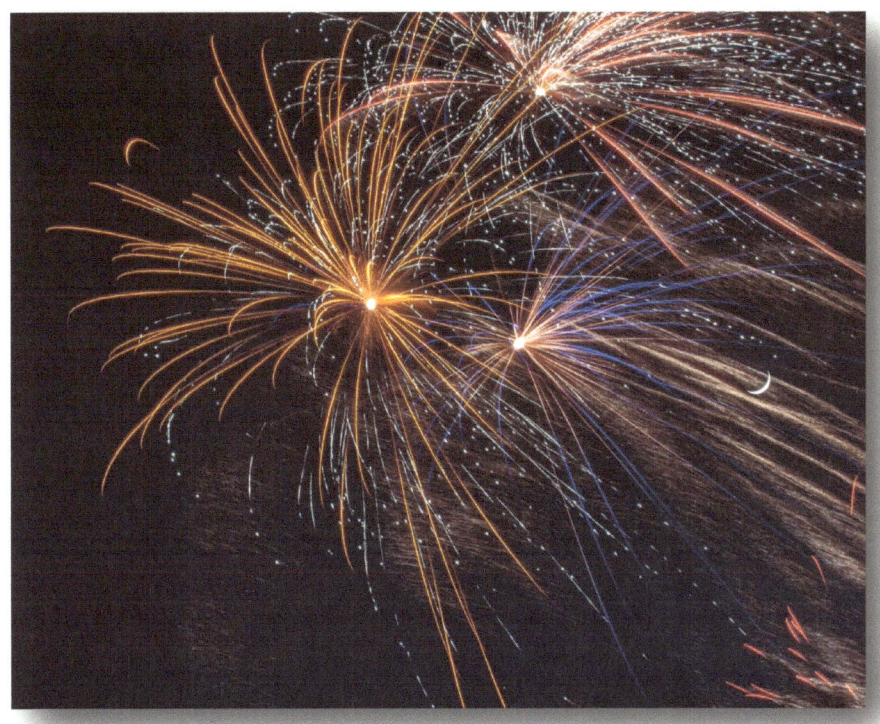

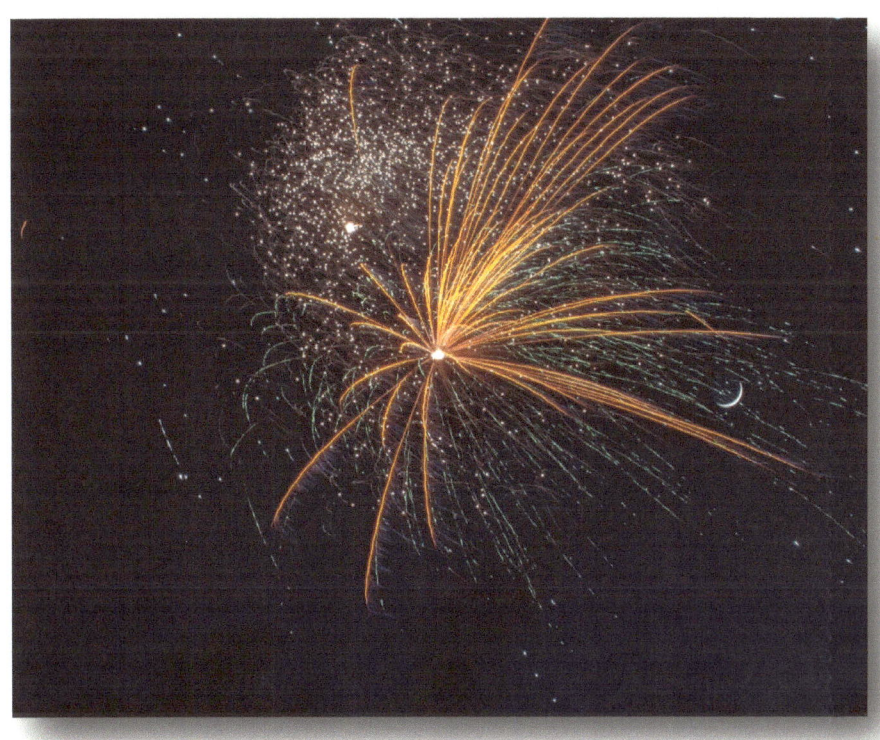

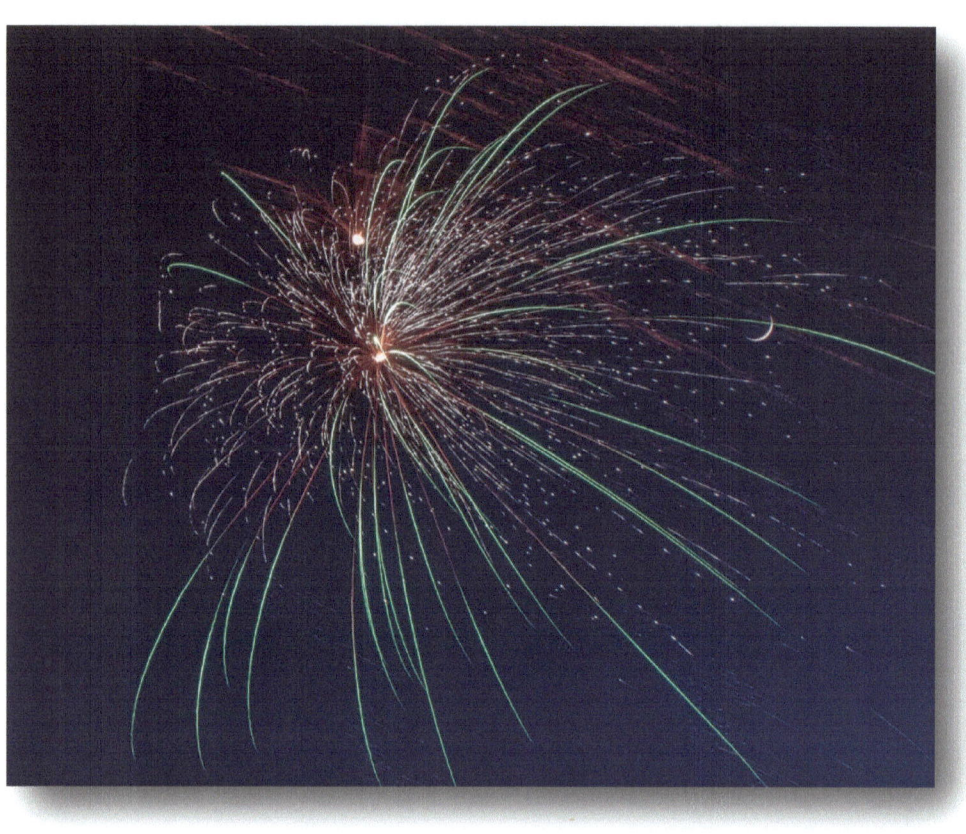

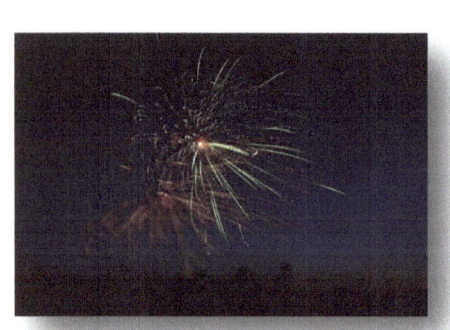
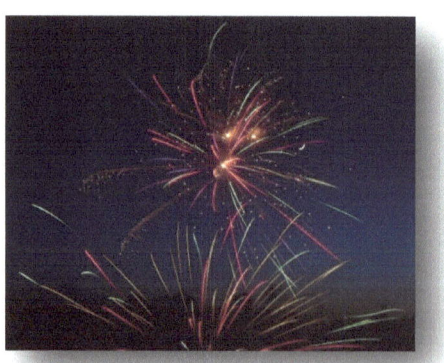

Long exposures allow multiple explosions to be captured.

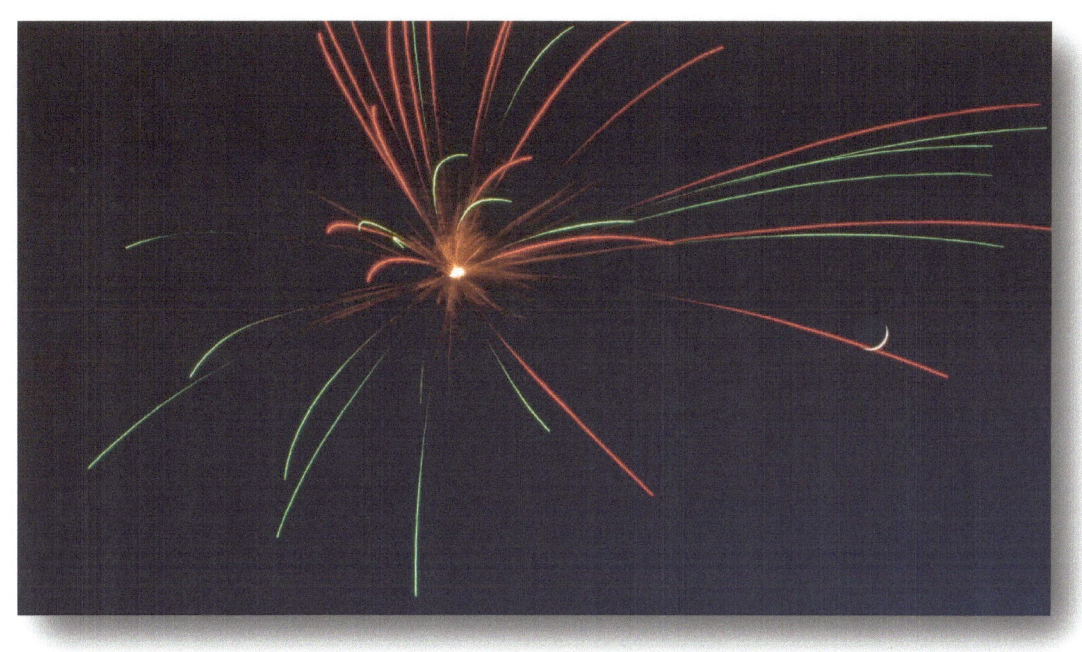

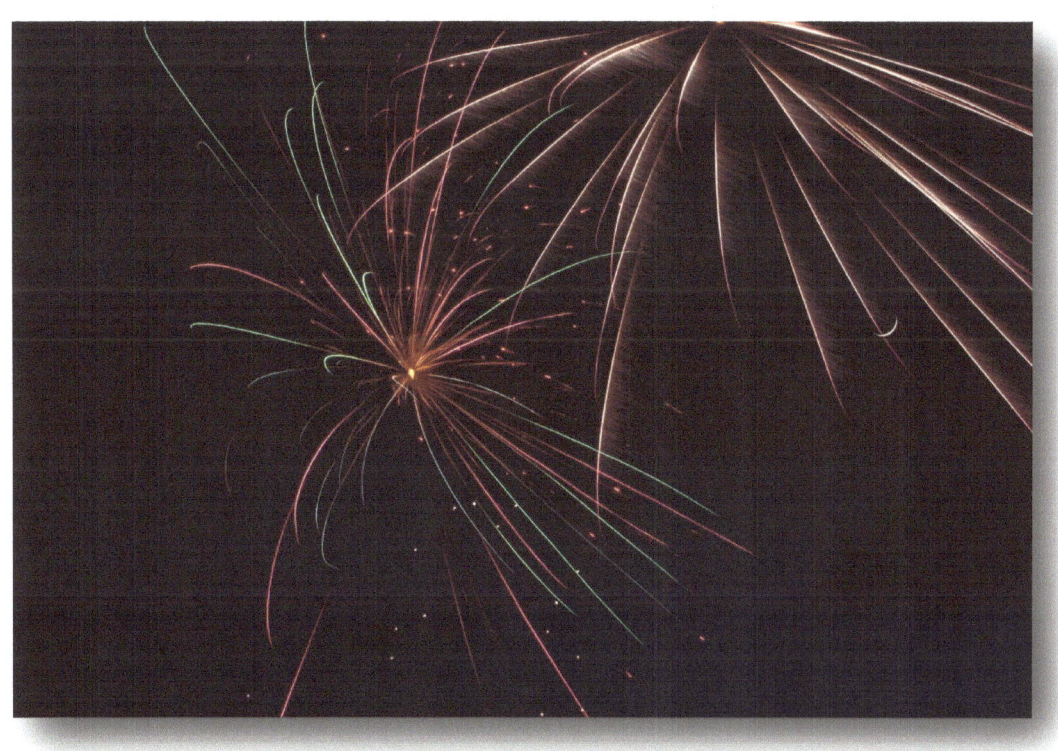

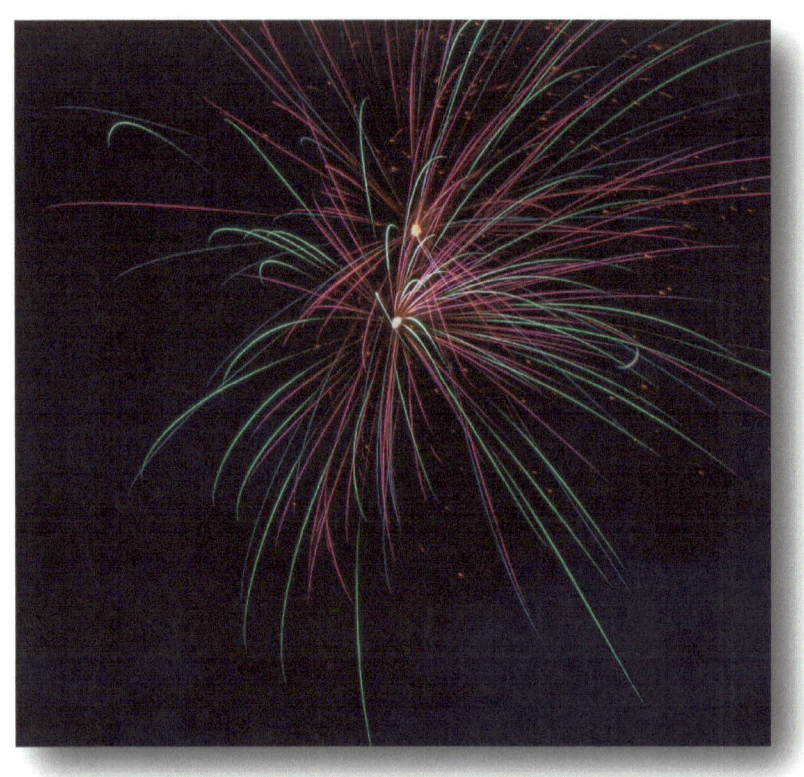
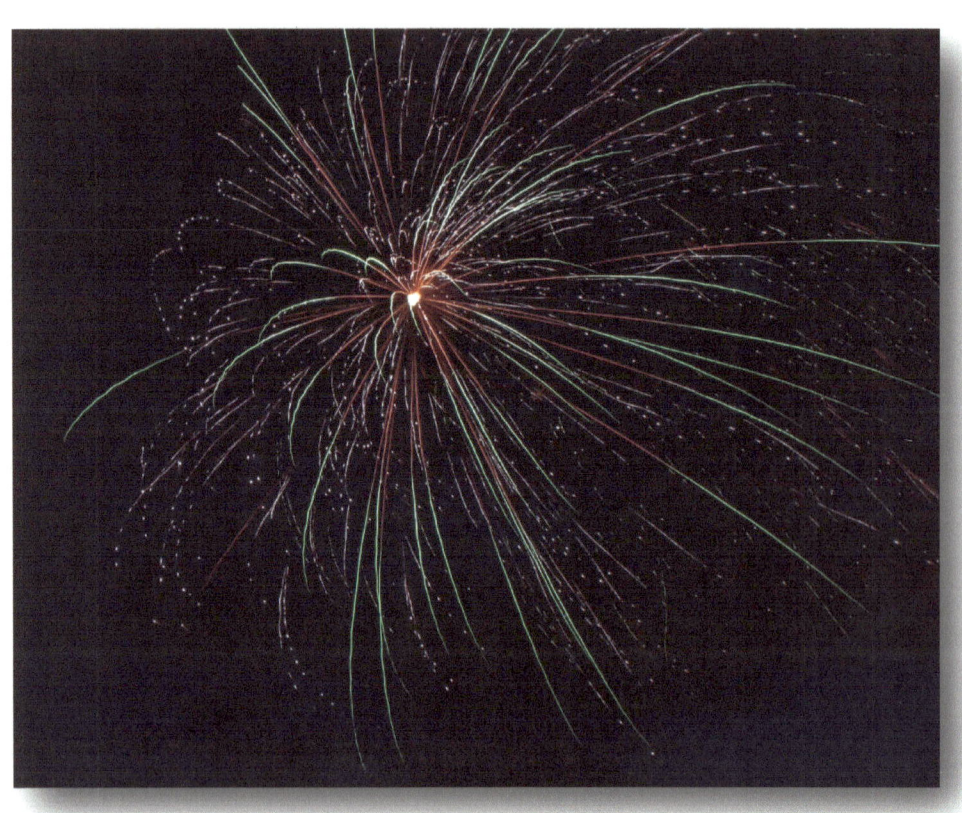

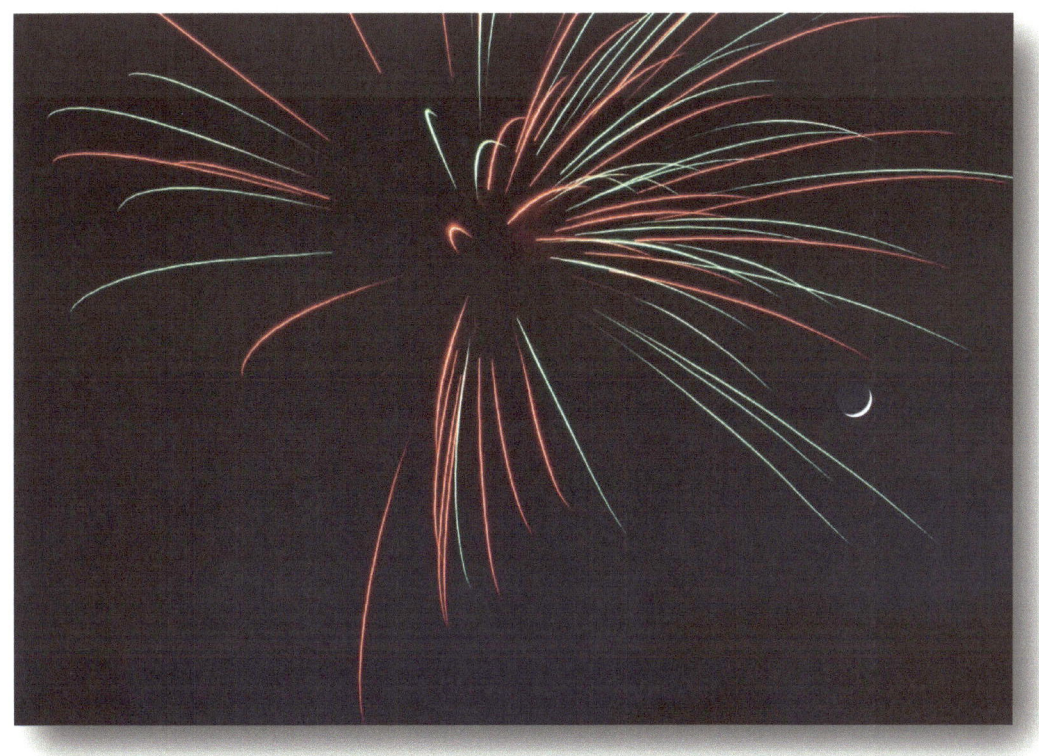
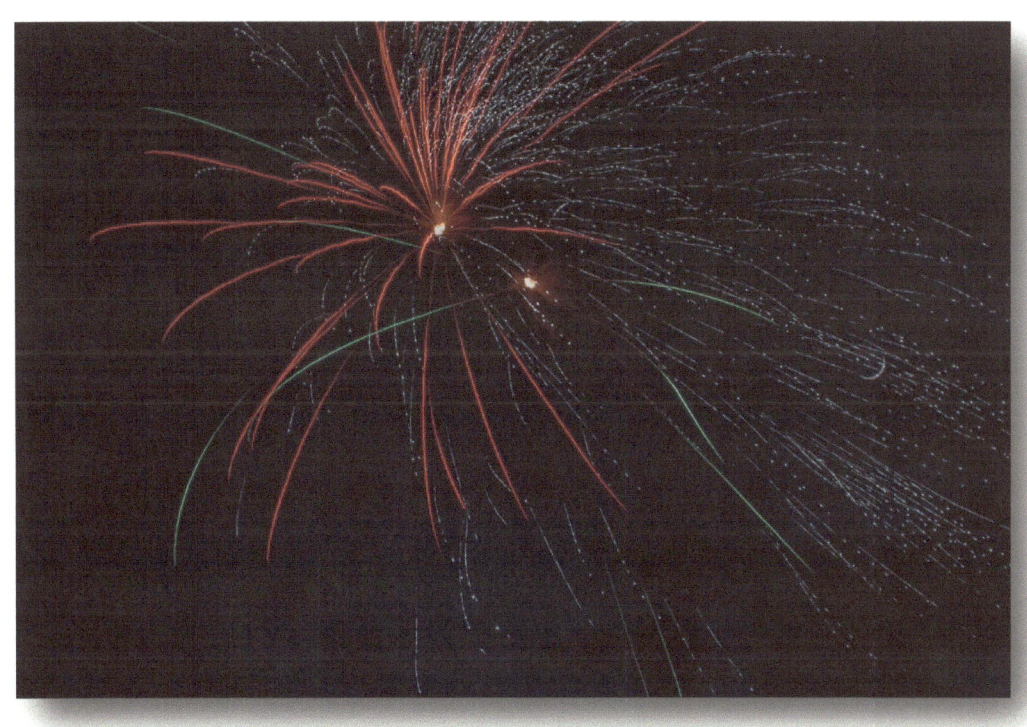

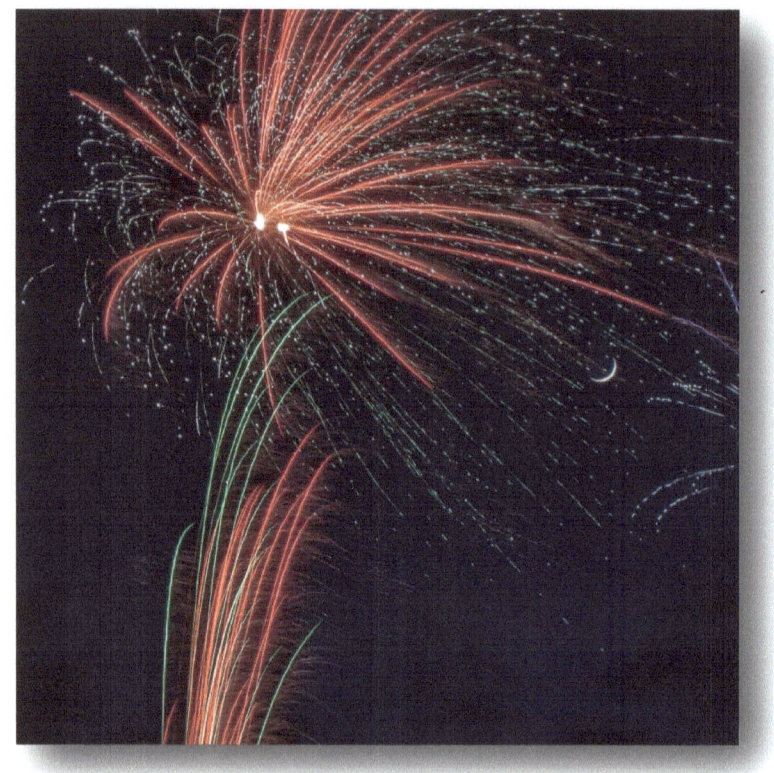
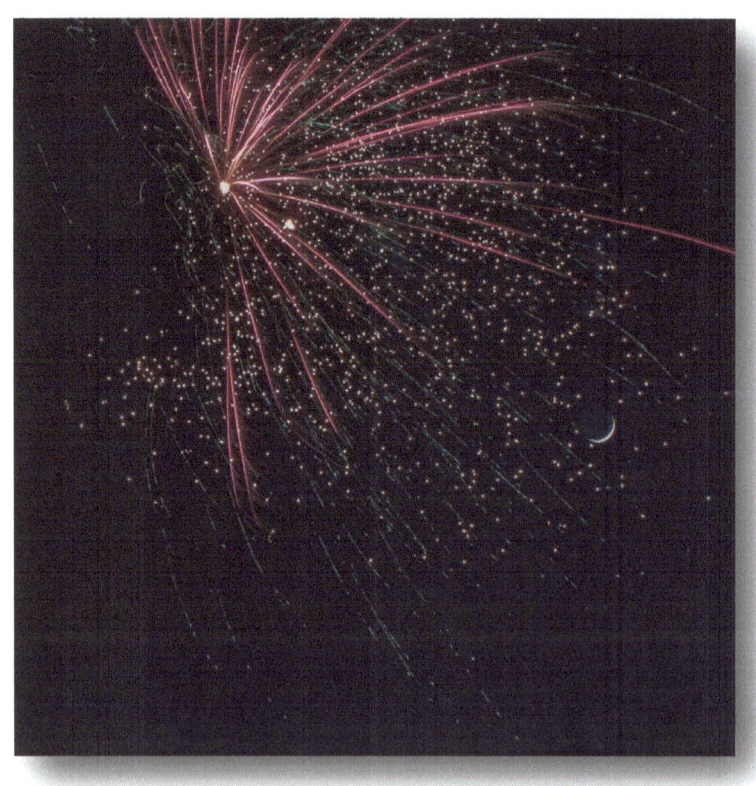

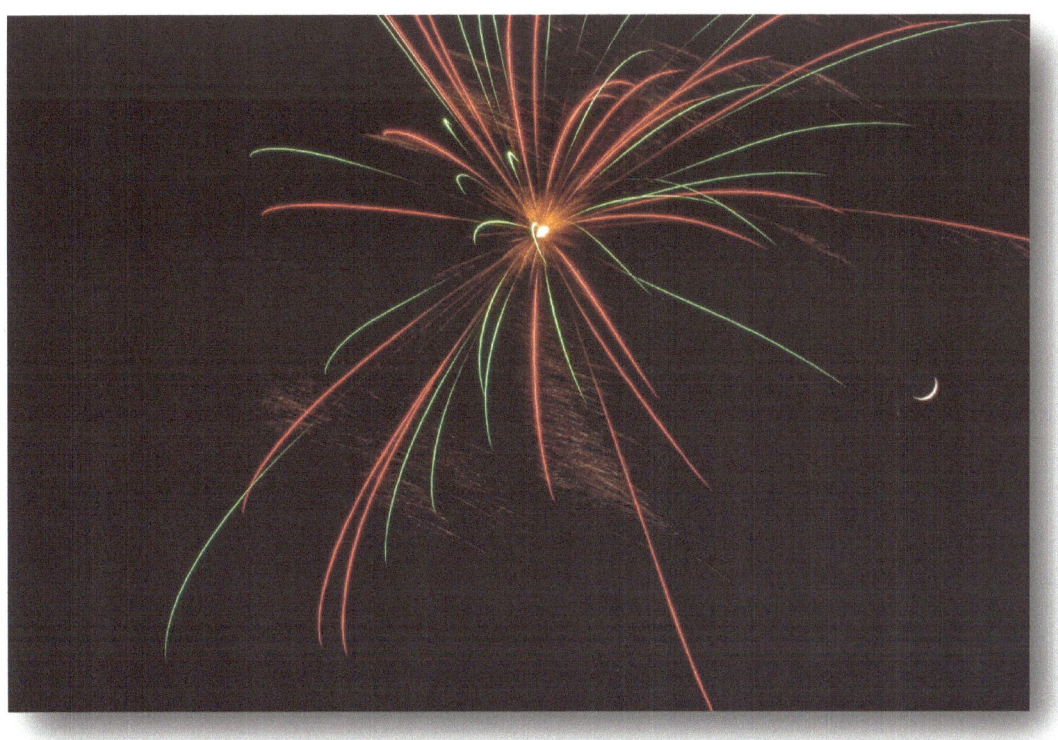
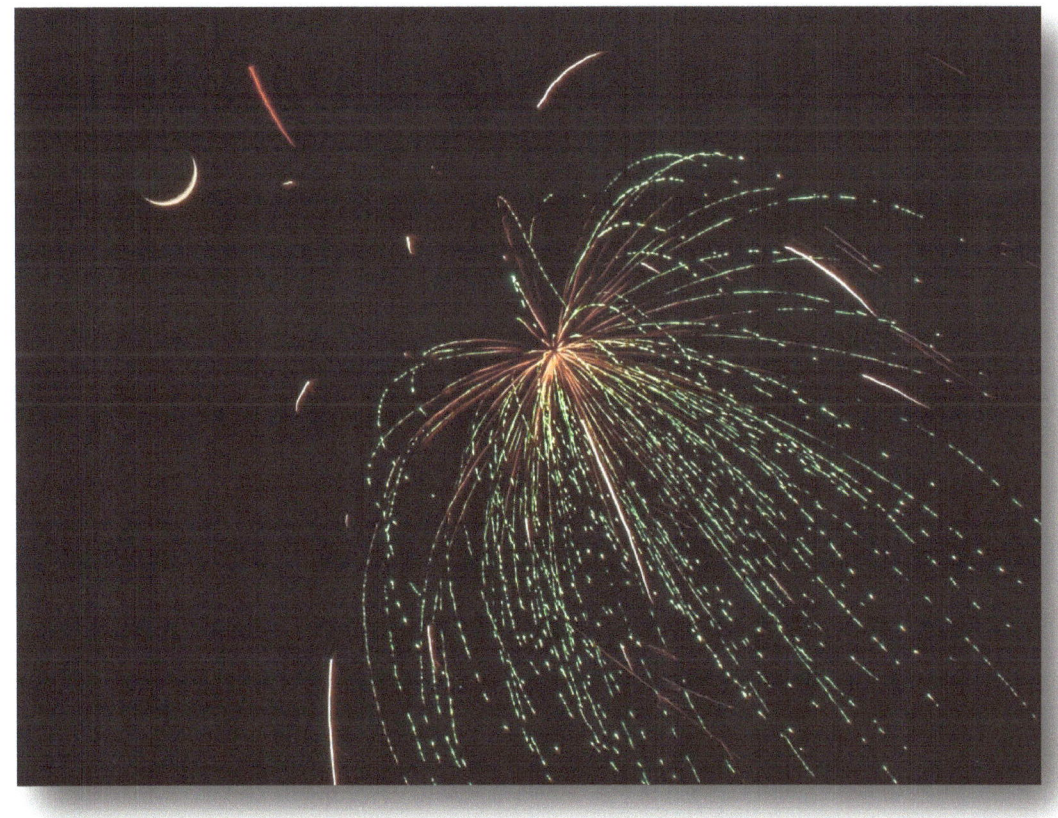

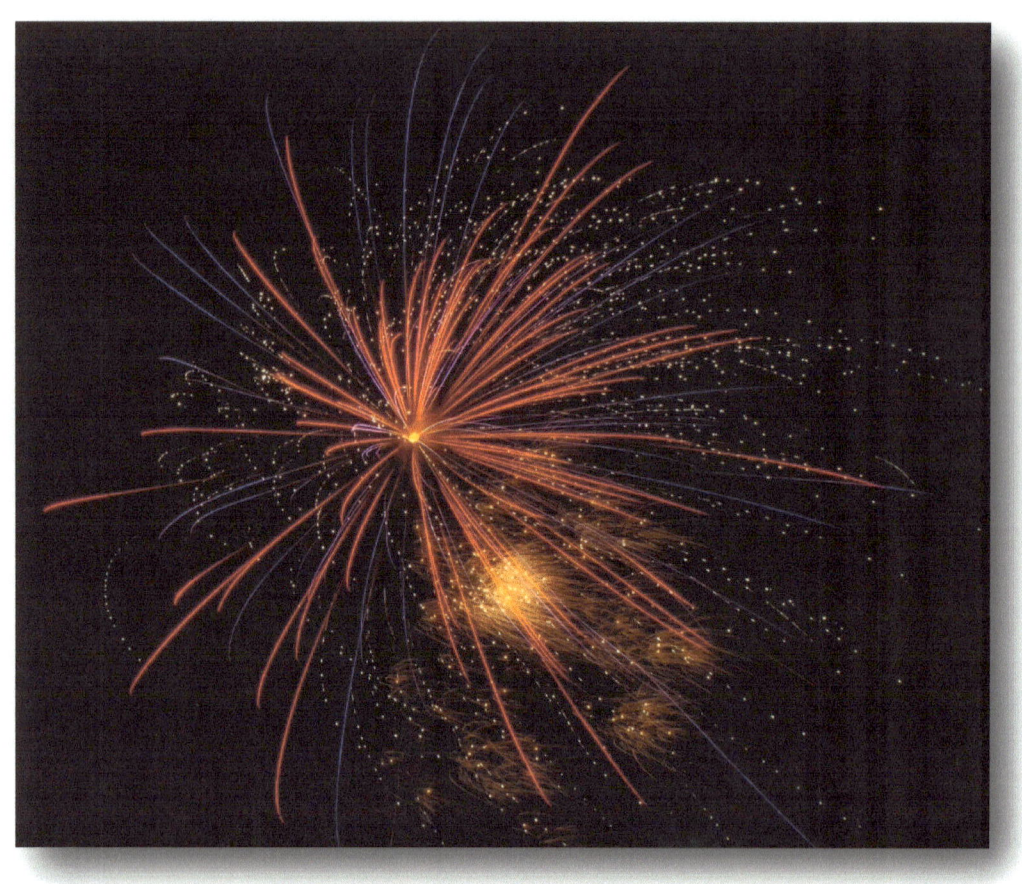
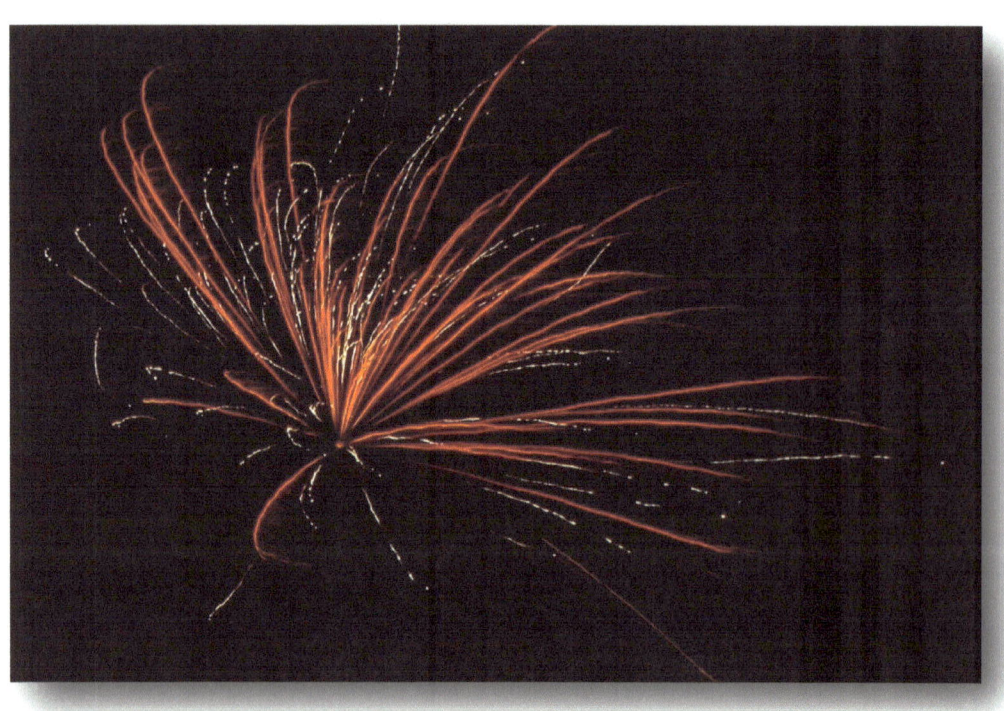

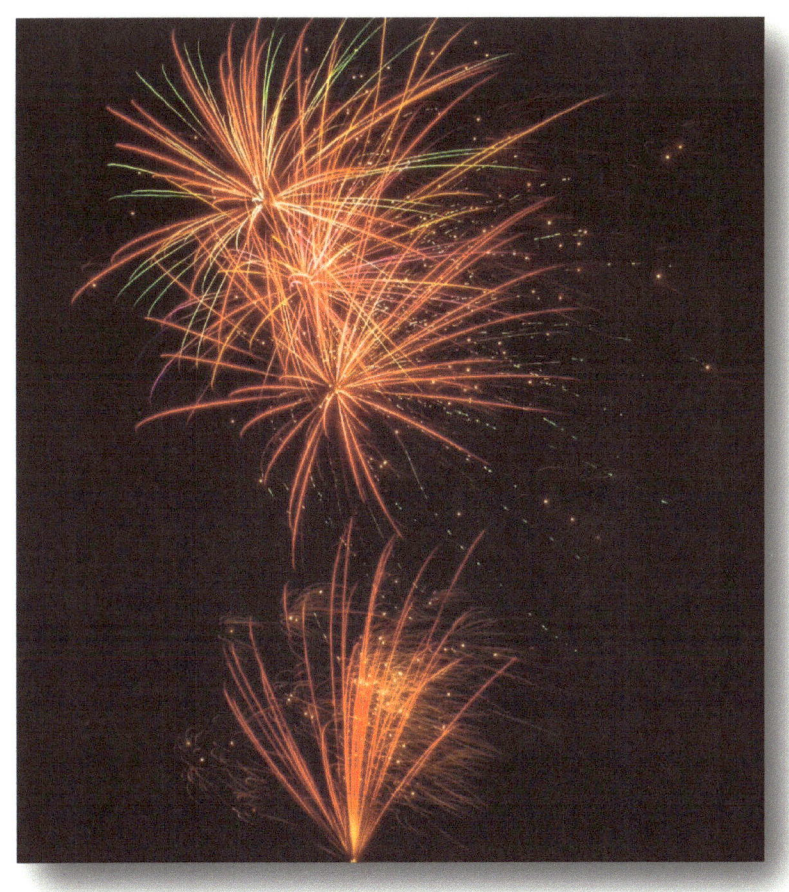
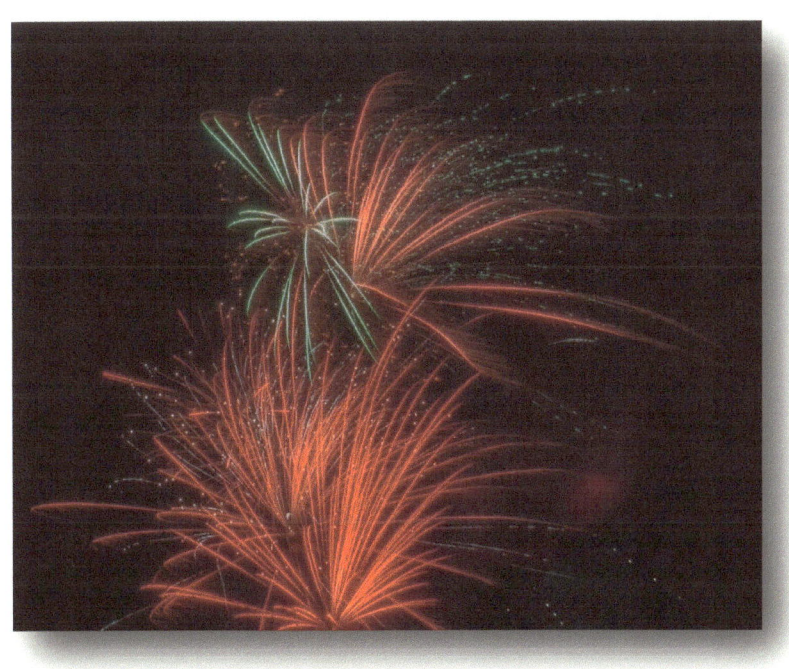

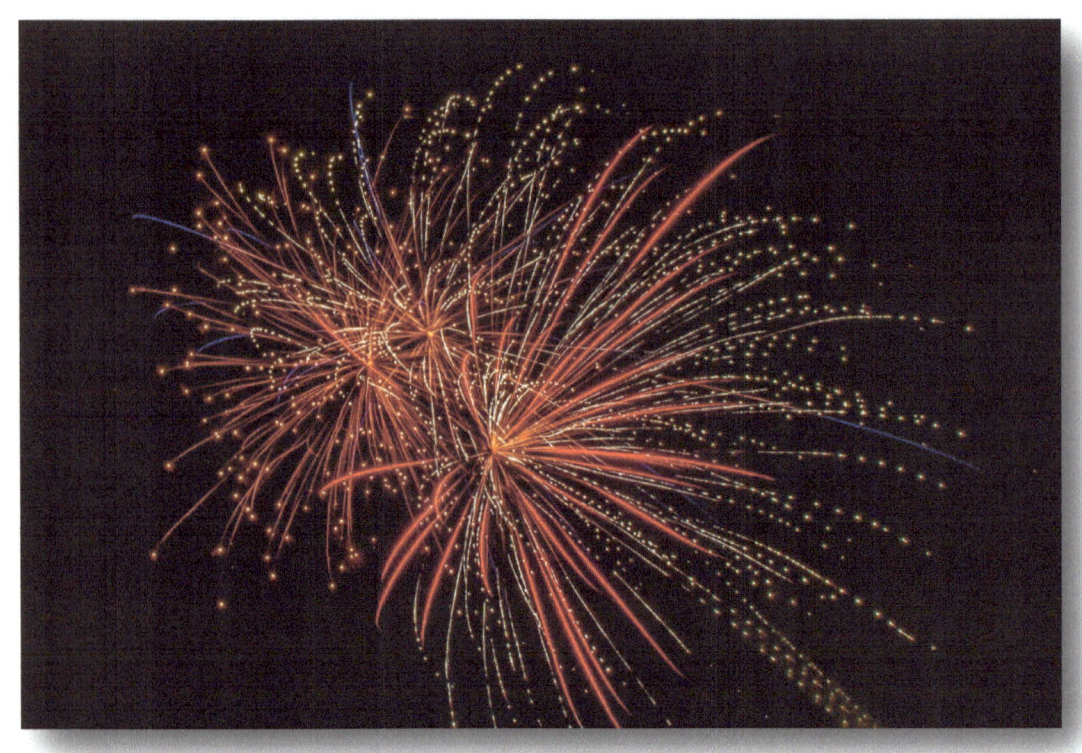

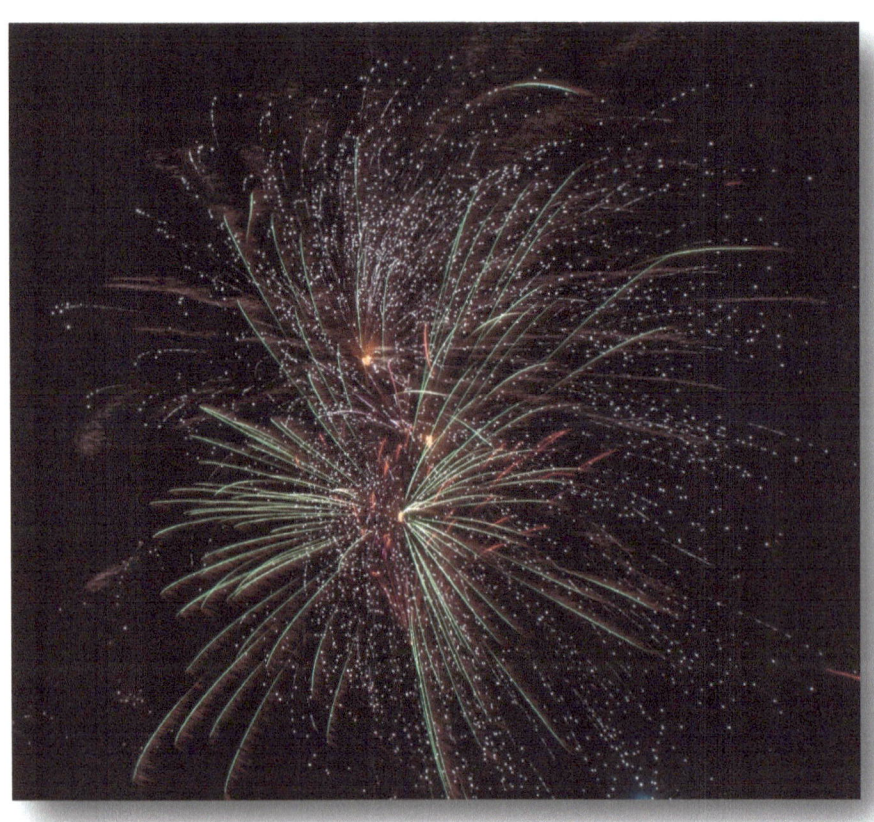

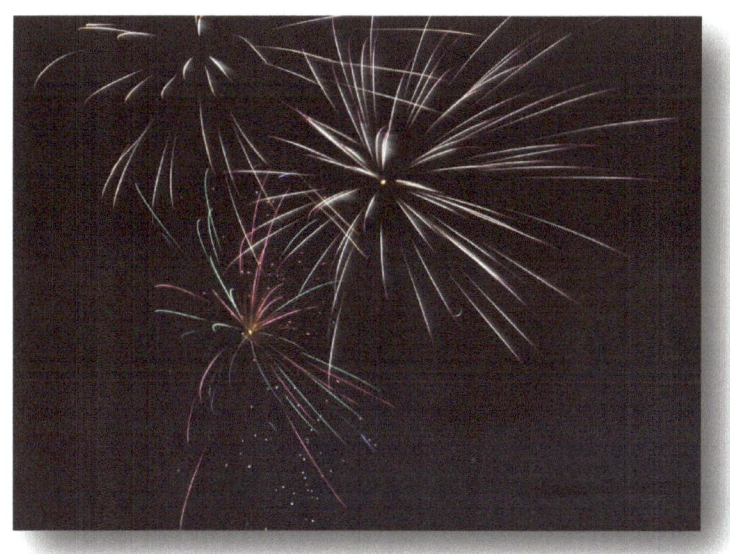
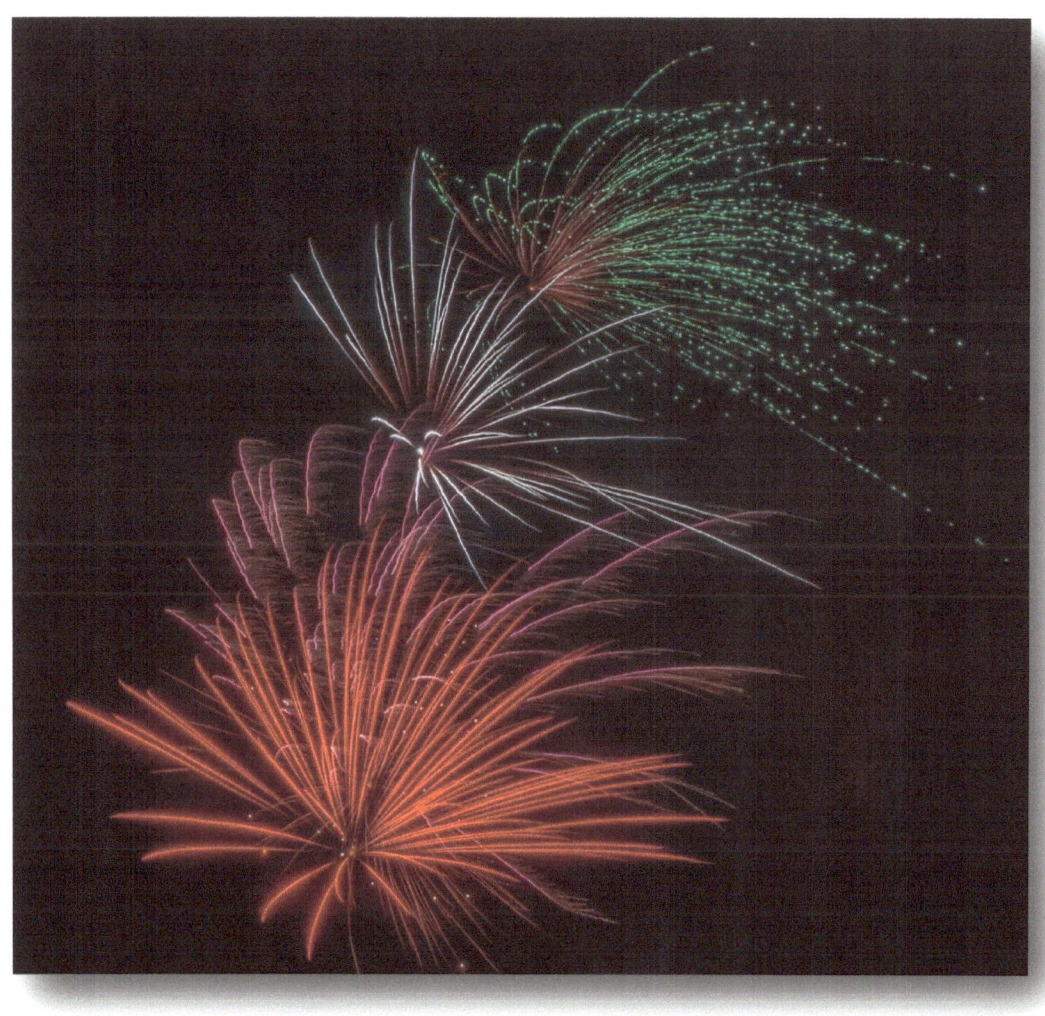

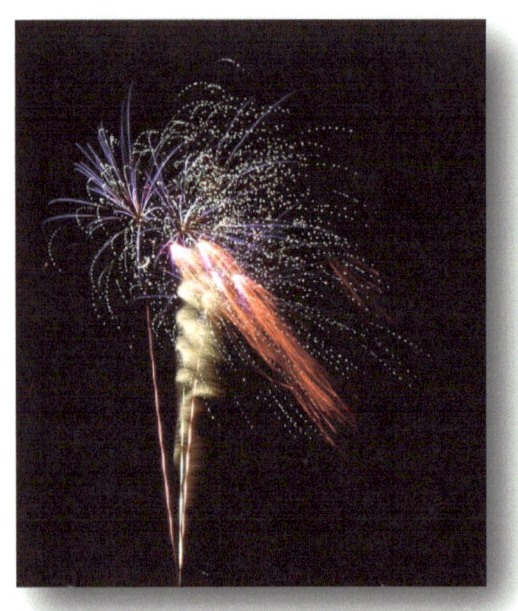
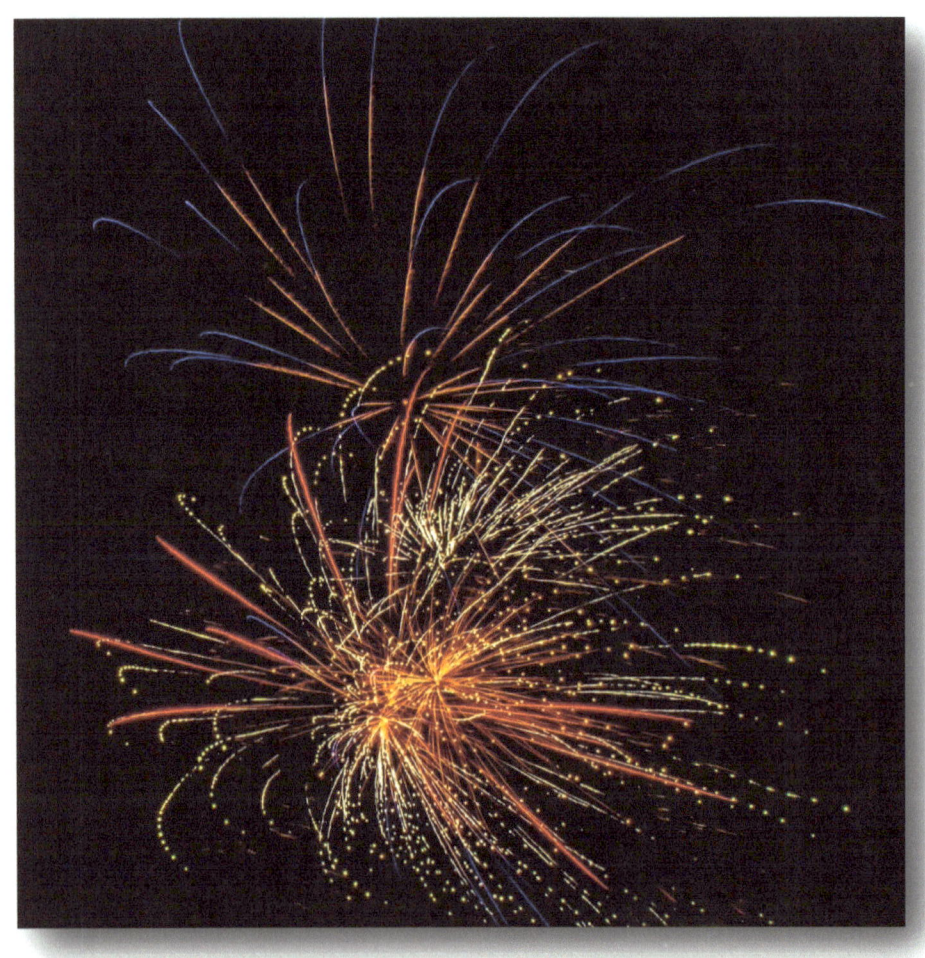

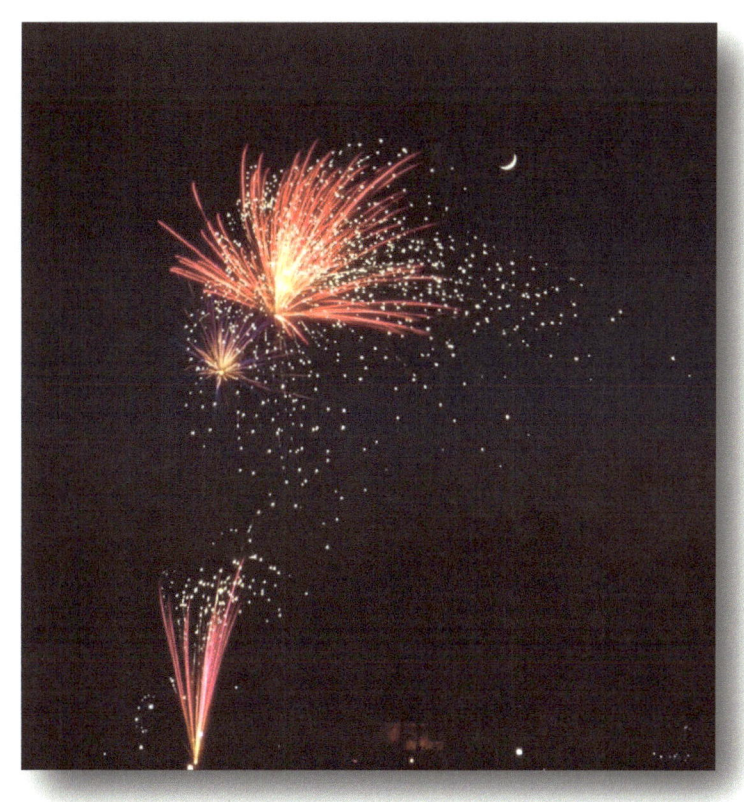
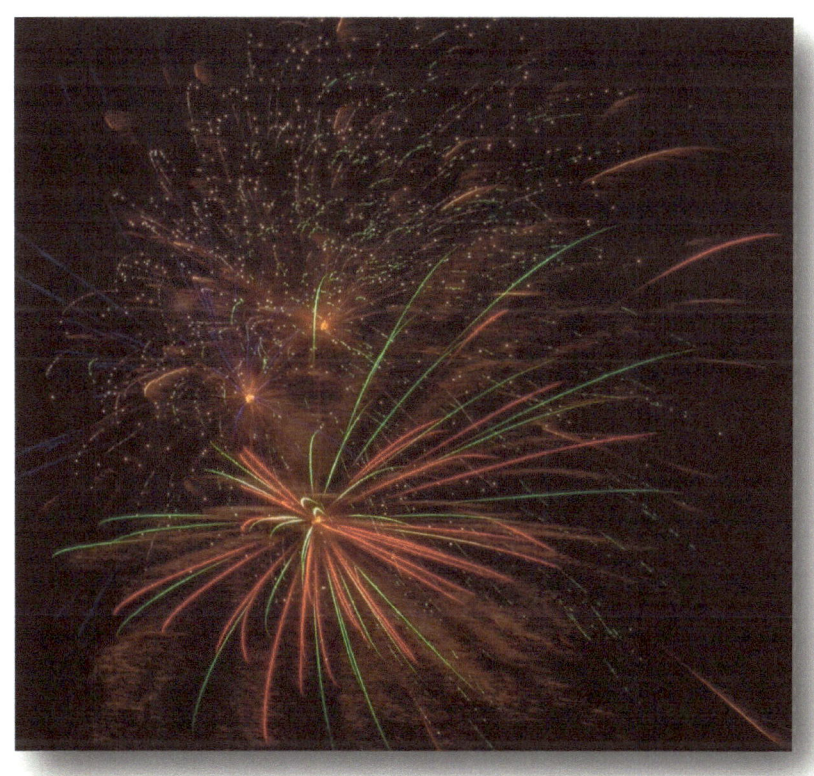

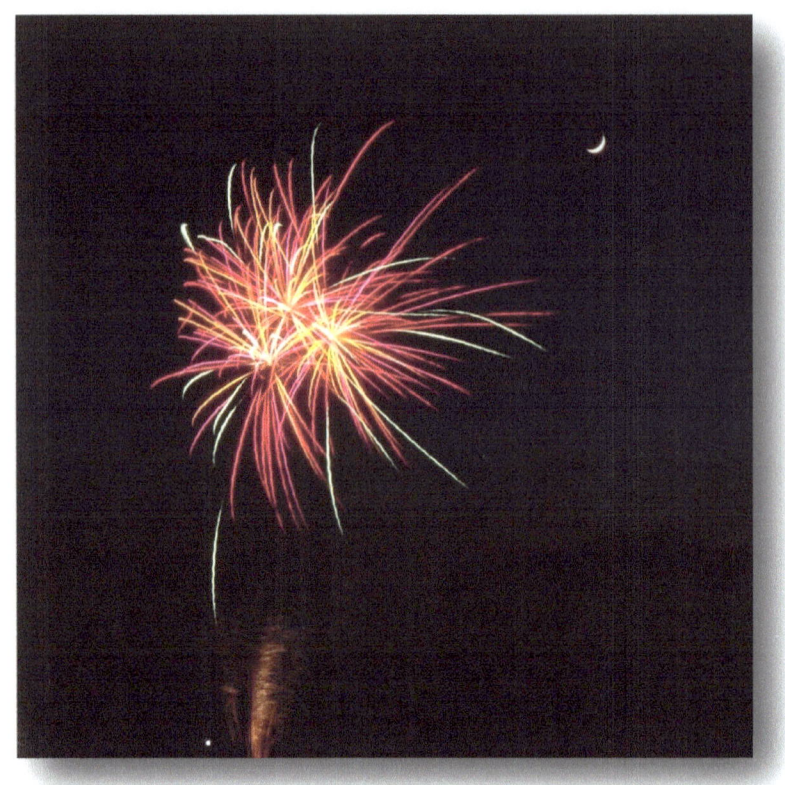
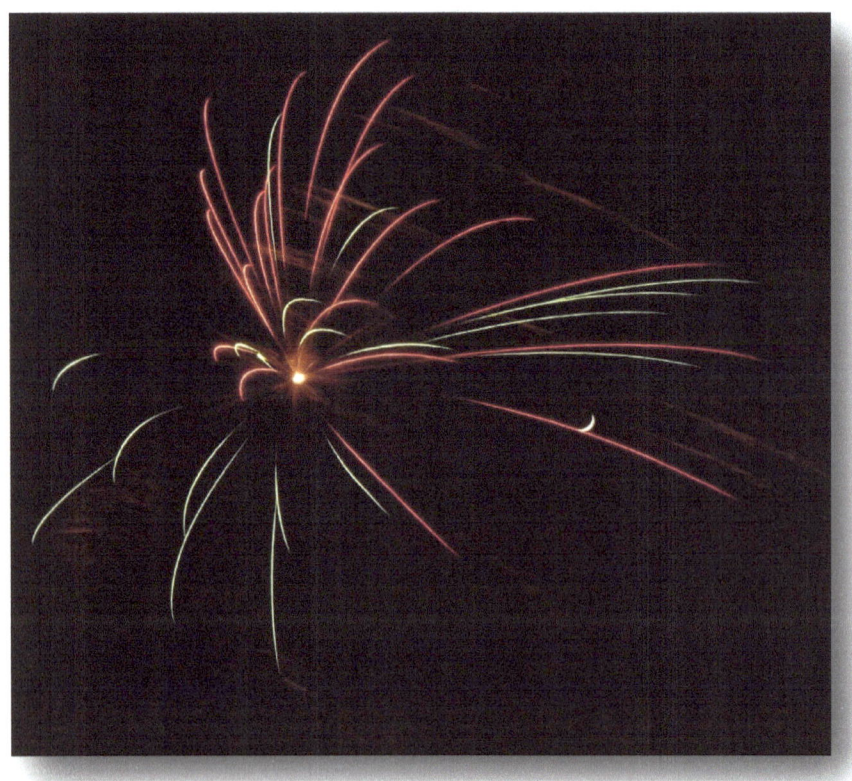

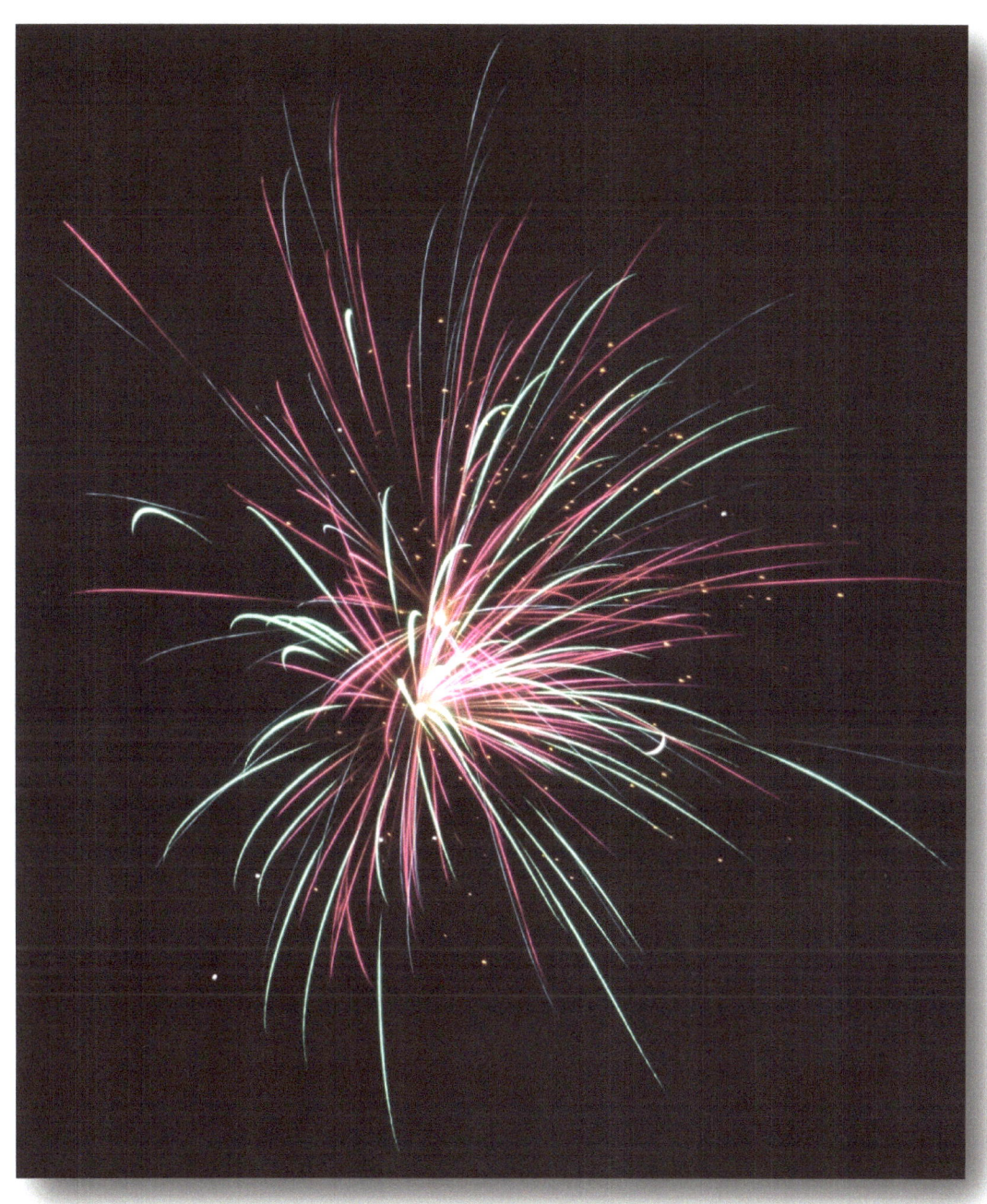

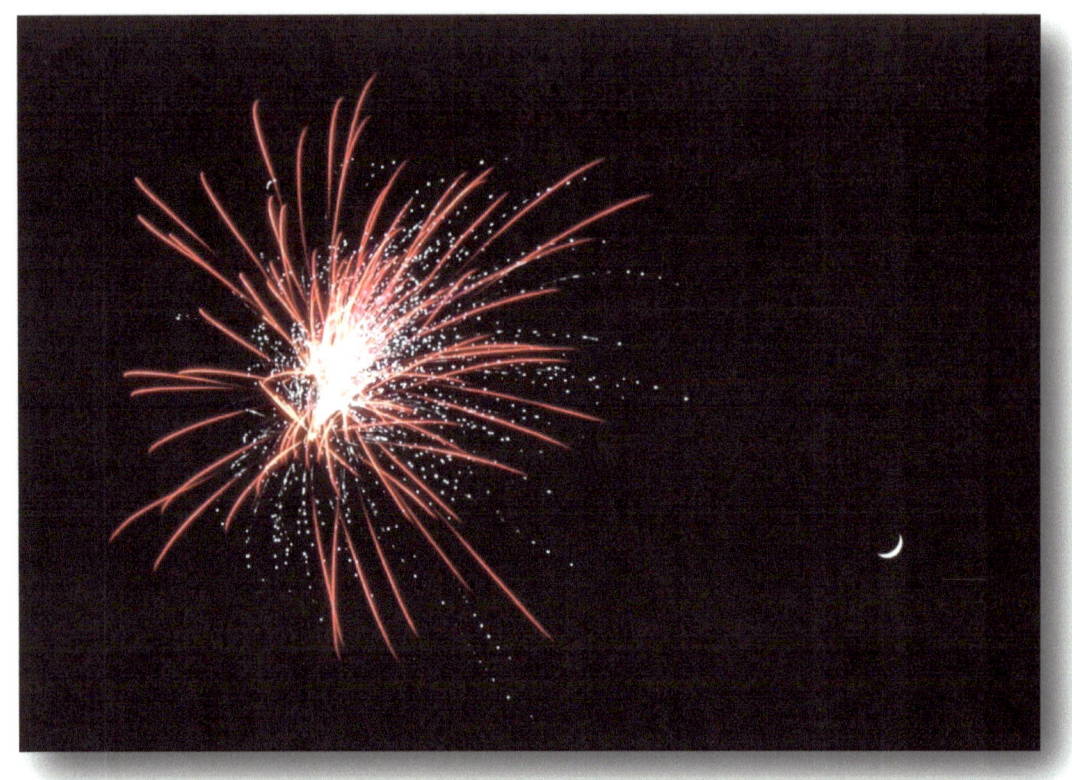

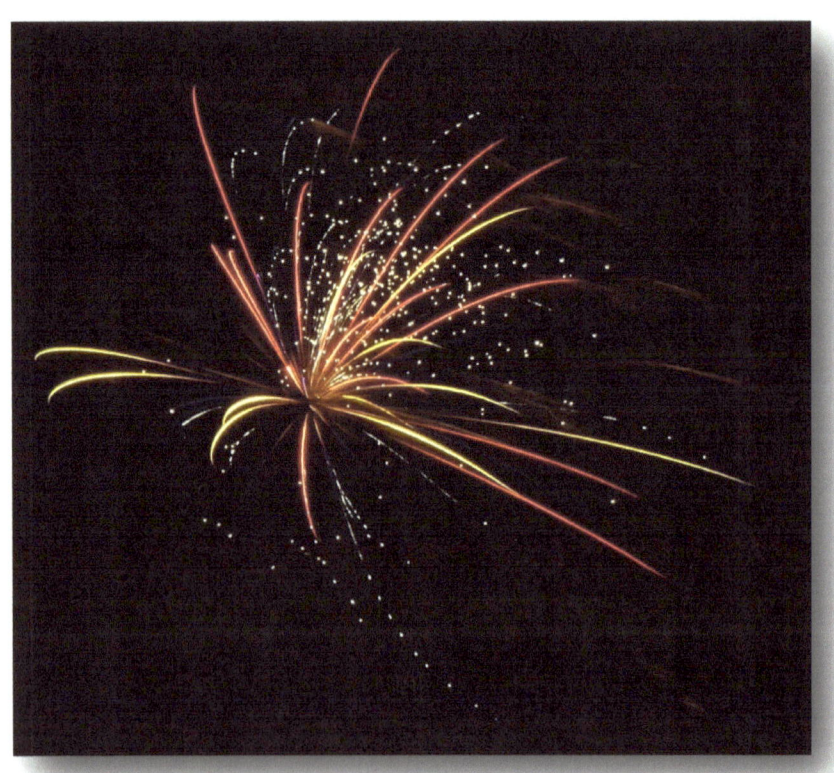

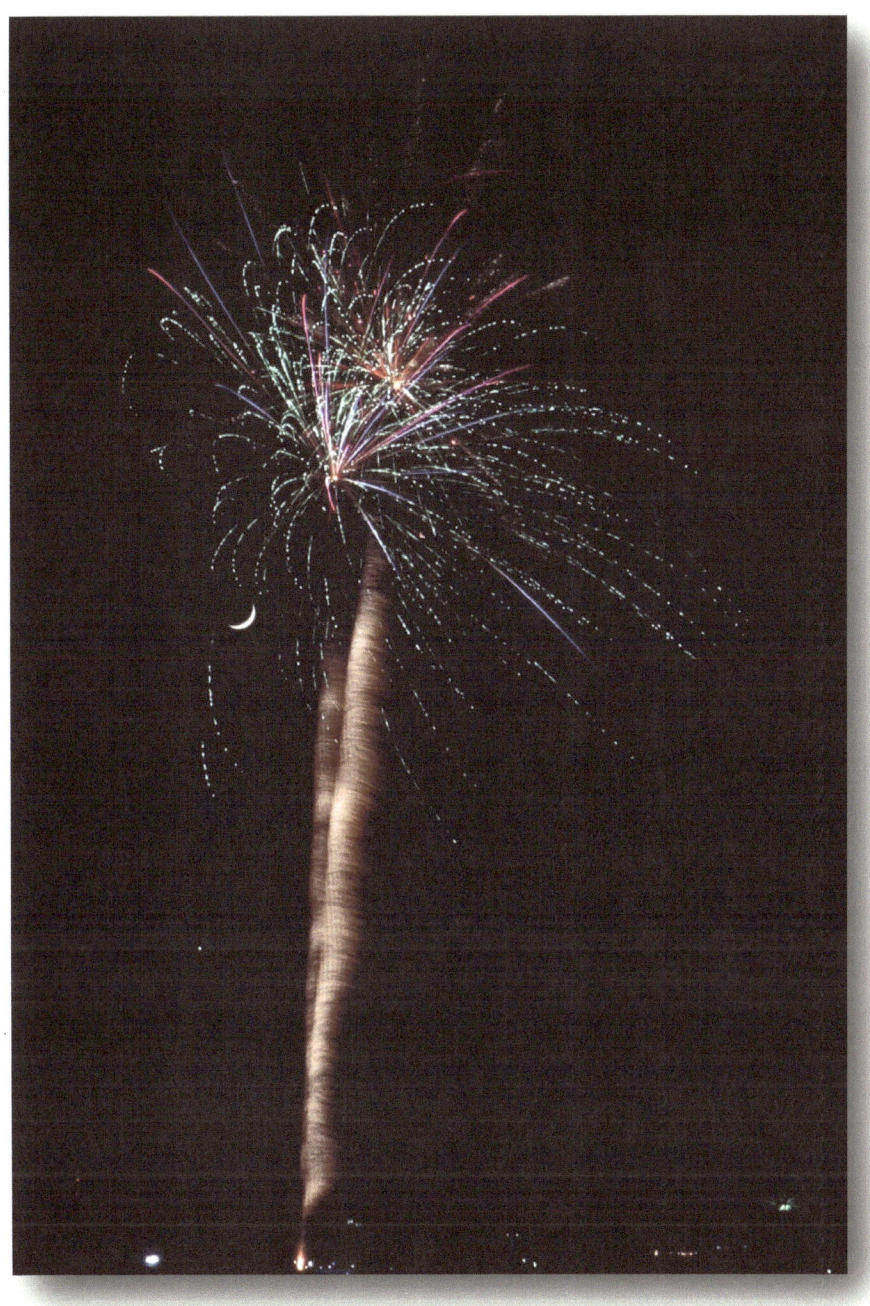

What a wonderful evening was had by all . . . now we look forward to next time. I hope you enjoyed these photos as much as I did in actually shooting them.

Susan Scott Smith

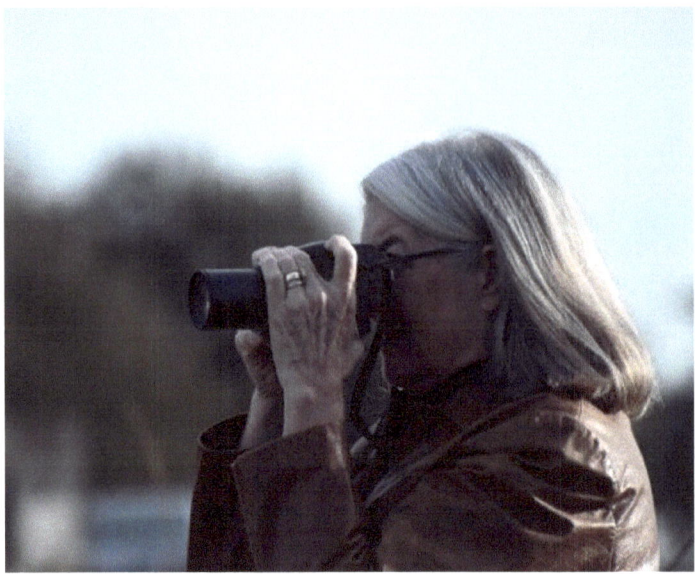

After retiring from teaching in 2013 I embarked on a new hobby that has turned into a very interesting, versatile, rewarding challenge. You can do anything with photography that you want. It can be shared privately with family and friends or with the world. It is possible to appreciate so many details around us not only in nature but in our manmade world also.

What a person does with a hobby is entirely up to them, but the future is limitless.

Additionally, I am involved with Galveston Art League and am the Membership Director. Some of my work hangs in the gallery from time to time, in restaurants where we have visited, and in photo albums for graduation pictures.

My husband and I have lived in a Motor Home (for the past 6 years) and have traveled a little and been able to enjoy a lot of different scenery when we have the urge. Our two Pomeranians (Miss Pepper & Jackson) LOVE traveling and seeing new areas as much as we do.

Around every new corner is a photo opportunity . . .

Email: S2the3rdPower@gmail.com

A Special Thanks To ...

My husband Tony who has been a great help with design and style . . . and patient to the Nth degree.

My parents, the Scotts, who have a fantastic work ethic and curiosity about learning new things.

Trudy LeDoux, my friend and photography instructor whose knowledge and understanding has been generously shared and empowered this work.

Paula Goffinett Scroggins, a fellow photographer, who invited me to see the fireworks near her neighborhood.

Roselyn Pierce-Shirley, whose books through Amazon/Kindle inspired me to stretch my wings and who helped me with editing.

Jim Malm, a fellow photographer, who shot my profile photo.

www.ingramcontent.com/pod-product-compliance
Lightning Source LLC
Chambersburg PA
CBHW041300180526
45172CB00003B/915